Stonehenge

A HISTORY IN PHOTOGRAPHS

Julian Richards

'HOW GRAND! HOW WONDERFUL! HOW INCOMPREHENSIBLE!'
SIR RICHARD COLT HOARE, 1811, *The Ancient History of Wiltshire*

Stonehenge is the world's most famous prehistoric monument and, since the middle of the 19th century, probably the most photographed. Using images from Historic England's unique photographic archive, *Stonehenge: A History in Photographs* charts the last 150 years in the life of this extraordinary and iconic site.

These largely unseen images touch on various moments in Stonehenge's history, from the leisurely tourism in the last years of Victoria's reign to the monument of today, a site visited each year by more than one million people from all over the world.

This book is a celebration of Stonehenge, in fascinating and often very human images. The text is written by archaeologist and television presenter Julian Richards, someone with a genuine love of Stonehenge.

Together they make *Stonehenge: A History in Photographs* the book for all who share a fascination with this magical monument.

Julian Richards comes from Nottingham and after discovering the joys of excavation, he read archaeology at Reading University.

From 1975 to 1997 he was a full time field archaeologist, directing in the 1980s the Stonehenge Environs Project, a major study of the prehistoric landscapes that surround Stonehenge.

After time working as an archaeological consultant and for English Heritage he became involved in broadcasting, initially with a BBC2 programme about how Stonehenge might have been built. This led on to *Meet the Ancestors* and since 1998 Julian has worked full time in broadcasting on Radio 4 (*Mapping the Town* amongst others) and BBC2 (*Ancestors* and *Blood of the Vikings*). He wrote books and created interactive web games to accompany both TV series.

A Fellow of the Society of Antiquaries of London, these days Julian combines broadcasting with writing and teaching to all ages and abilities. His other books for English Heritage and Historic England include the Stonehenge guidebook (2005), *The Incredible pop-up Stonehenge* (2005) and *Stonehenge – the story so far* (2nd edition, 2017).

The photographs in this book come primarily from Historic England Archive. This is an unparalleled archive of 12 million photographs, drawings, reports and publications on England's places. It is one of the largest archives in the UK, the biggest dedicated to the historic environment, and a priceless resource for anyone interested in England's buildings, archaeology, landscape and social history. Viewed collectively, its photographic collections document the changing face of England from the 1850s to the present day.

Historic England Archive
www.historicengland.org.uk/images-books/archive/

Historic England

Stonehenge
A HISTORY IN PHOTOGRAPHS
Julian Richards

Published by Historic England, The Engine House, Fire Fly Avenue, Swindon SN2 2EH

www.HistoricEngland.org.uk

Historic England is a Government service championing England's heritage and giving expert, constructive advice.

First published 2004

Reprinted 2006, 2009 (with corrections), 2014, 2017

Product code 51866

British Library Cataloguing in Publication data
A CIP catalogue record for this book is available from the British Library.

Typeset in Univers LT Std 47 Cn Lt 8.5pt

Edited by David M Jones

Indexed by Julian Richards

Cover and page layout by Mark Simmons

Printed in the Czech Republic via Akcent Media Limited.

Front cover: Stonehenge, a much loved, but crumbling ruin in the late 19th century (NMR W78)

Back cover: The approach to the stones by the road from the east, c 1930 (NMR MPBW Photographs Collection)

Acknowledgements

I would like to thank all of English Heritage's production team at the National Monuments Records Centre (NMRC) in Swindon. Val Horsler made an innocent enquiry about whether or not I had any spare time, which led to my involvement in the production of this volume. Thank you to Val for giving me the chance to immerse myself in the National Monuments Record's wonderful collection of Stonehenge photographs. David M Jones has been my managing editor, the one to drag me out of the photographic archive and make sure that the production schedule was not compromised by my ability to become distracted by fascinating ephemera. The text, which has benefited from David's incisive editing, was also read by Annette Lyons who, as a non-archaeologist, pointed out the bits that didn't make sense. Caroline Broughton did a splendid job chasing photographs and without her diligence the book would be visually the poorer. I would also like to thank members of the NMRC staff who painstakingly found and prepared the photographs, including Lindsay Jones (NMR Services), Robin Steward (Plans Room), and Ian Savage and Rachel Gale (Photographic Services).

Beyond the National Monuments Record I would like to thank the Wiltshire Heritage Museum at Devizes, the Wiltshire Record Office in Trowbridge and English Heritage's office in Amesbury for the use of their photographs. Individuals include Alan Lodge, Peter van den Berg, Les Wilson and especially Richard and Jodeane Albright not only for their photographs but for sharing with me their experiences of Stonehenge.

Fiona Sims-Farn, English Heritage's Corporate Records Manager was enormously helpful in retrieving Stonehenge files, both ancient and modern, that enabled me to understand the stories behind the pictures.

Contents

Introduction

HOW GRAND! HOW WONDERFUL! HOW INCOMPREHENSIBLE!

— Stonehenge in the words of the pioneering 19th-century archaeologist Sir Richard Colt Hoare.

Stonehenge is arguably the most famous prehistoric site in the world. Its huge stones and the structures they form are instantly recognisable, a powerful image of ancient achievement. Each year nearly a million people, from all over the world, visit Stonehenge and between them they take millions of photographs. To these visitors photographs are a cheap and easy way of capturing a place or a moment in time. Even the cameras that take the pictures can be disposable, while digital images can be sent around the world in seconds. Today's photographers are carrying on a tradition that started more than 150 years ago, in the early days of photography, when taking pictures was far from easy, and far from cheap.

Most of today's images of Stonehenge are destined to remain private; personal souvenirs tucked away in an album or stored as a computer file. But English Heritage, the guardian of Stonehenge, also has its souvenirs, although on a somewhat larger scale. In the National Monuments Record (NMR) at Swindon are thousands of photographs, accessible to the public but largely unseen. This remarkable collection, which starts with a single photograph taken in 1853, shows the many faces of Stonehenge, from picturesque ruin to building site, its stones leaning drunkenly, scaffolded, daubed with graffiti, cleaned by long-suffering staff and garlanded by Druids. This is the 'official' collection and a selection of the photographs that it contains forms the basis for this book. It has been a great pleasure to wander through this treasure house, frequently sidetracked by the personal details of Stonehenge and of those who have explored it over the years. But as the 'official' collection it tends to be biased towards times of great activity at Stonehenge, the two great 20th century campaigns of excavation and restoration and in particular the work carried out in the 1950s and 1960s. I have consequently taken the liberty of including a few images from other sources, primarily from the Wiltshire Record Office in Trowbridge and from the Wiltshire Heritage Museum in Devizes. These help to add a more 'social' flavour to the story. I also found some fascinating and unusual photographs in English Heritage's Stonehenge office in Amesbury.

In Stephen Croad's English Heritage book *Liquid History* the photographs of the Thames show a physical journey, from the source of the river to the sea. But in this companion book about Stonehenge the journey is not in place, but in time. All the photographs, spanning more than150 years, are of one place. On the whole they are shown in the order in which they were taken although certain themes can be identified where the story can best be told by mixing photographs from different eras. Together, what these images convey is a sense of the changing public face of Stonehenge.

At first visitors are few, they arrive on foot, in carriages and certainly not in crowds. They find no restrictions to wandering freely, clambering on the stones (and apparently carving their names on them). Then they cycle to Stonehenge, or arrive on traction engines, and as their numbers increase, so do the restrictions. Cars and coaches are accompanied by fences and protests, ticket offices and custodians. Grass is replaced by gravel, in turn replaced inevitably by more grass. The Druids appear at regular intervals, as do Pagans, Christians and Morris Dancers and those who visit become both more numerous and at times more eccentric.

The photographs also chart a journey of understanding, however, in which each new excavation provides more, if sometimes confusing, evidence, and ideas about the ancient past change with new developments in archaeology and science. The work of the last few decades has taught us more about Stonehenge than the preceding centuries of speculation. But despite all that science has told us, Stonehenge remains an enduring mystery.

What emerges from these photographs is the Stonehenge of today, a restored ruin, a powerful symbol of antiquity, a major tourist attraction and to some, still, a temple as holy as it was when it was built more than 4000 years ago.

Julian Richards

July 2004

The Antiquarian View of the Ancient Past

Photographs provided an instant, or in the case of early photographs, a comparatively instant means to capture an image of Stonehenge. But centuries before the first camera appeared, this great curiosity, this jumble of stones on Salisbury Plain had been the subject of countless drawings, paintings and engravings. Stonehenge first appears, both in a rather squared up form and in the process of being built by Merlin, in a 14th century manuscript illumination. It appears frequently from the 16th century onwards, and, although the focus is always the stones, they appear in landscapes that range from the straightforwardly realistic to the wildly fanciful. Mountains, wild looking Druids and even medieval stone castles, appear at the whim of the illustrator, many of whom have clearly never visited Stonehenge. Over these centuries, as the image of Stonehenge changed, so too did people's ideas about the ancient past. At varying times Stonehenge was seen as a monument to the Romans, the Danes and even the Phoenicians, while in the early 18th century the antiquarian William Stukeley reinforced the link with the Druids that has persisted to the present day.

If the 18th century was the era of the antiquarian, then the one that followed, a century of extraordinary and far-reaching change, saw the emergence of the archaeologist, using science to investigate the past. In the early 1800s Stonehenge came under the gaze of a true pioneer, Sir Richard Colt Hoare of Stourhead House in Wiltshire. Colt Hoare was the young heir to a banking fortune, but showed no interest in the family business. Instead he became obsessed with the past and determined to write the *Ancient History of Wiltshire*. In this self-appointed and truly monumental task he was fortunate to find an invaluable collaborator, William Cunnington, a tradesman and self-taught archaeologist from the Wiltshire village of Heytesbury. Together this unlikely pair would prove to be a formidable team.

Colt Hoare was inevitably drawn to Stonehenge; it was a magnet for his curiosity. Not only a unique and enigmatic structure in its own right, it was also surrounded by great cemeteries of ancient burial mounds, or 'barrows', irresistible to someone described by his friends and colleagues as 'barrow mad'. Here Colt Hoare and Cunnington made some of their greatest and most spectacular finds. The barrows they dug into yielded pots, some plain, some highly decorated, weapons, tools and ornaments of stone, bronze and iron, beads of jet, amber and glass, even golden treasures. But Colt Hoare and Cunnington had difficulty in interpreting their finds, lumping them all together as 'British' or 'Ancient British' and struggling with the idea of time. The view in the early 19th century was that the world had been created in 4004 BC, a date calculated by Archbishop Ussher and given authority by being printed in the margin of the Authorised Version of the Bible. This gave just short of 6000 years into which everything that the past could offer had to be fitted. This included fossils, the bones of extinct creatures, everything made by humans and, of course, Stonehenge itself. Even within this timescale there was the additional problem of how to place objects in chronological order. Were stone tools older than iron tools? Where did bronze fit in? Colt Hoare and Cunnington were aware of the theory that there might have been three successive ages, of Stone, Bronze and Iron, but it would be many years before this basic scheme for dividing ancient time would be widely accepted.

This then was the concept of the ancient past, the age of Stonehenge, that was shared by Colt Hoare and his contemporaries, a biblical timescale, based on the date of Creation, a time of 'Ancient Britons'. It is therefore most fortunate for us that Colt Hoare was also aware of the value of simple observation and recording, instructing his wonderful draughtsman, Philip Crocker, to make detailed drawings of Stonehenge for *Ancient Wiltshire*. Crocker's 'general ground plan' surveyed in 1810 and published in 1811, is a model of accuracy and objectivity and can still, after nearly 200 years, be used with confidence to describe the structures that make up Stonehenge.

Moving from the outside inwards, the first part of the structure of Stonehenge that is encountered is the circular ditch and bank, with its most obvious entrance to the north-east. The entrance extends out into the low banks and ditches of the Avenue, creating a long formal approach way. Even in 1810 the Avenue was cut by what at that time was described as the 'Road to Shrewton and Heytesbury', in more recent years the busy A344. Close to the edge of the road and within the line of the Avenue is the 'Heel Stone', a huge unshaped upright boulder, not named on the plan but referred to by Colt Hoare as 'the Friar's Heel'. Another stone, roughly shaped and known as the 'Slaughter Stone', lies horizontal just inside the entrance to the circular earthwork enclosure. Colt Hoare was very dismissive of the suggestions that this was where victims of sacrifice were slaughtered, noting quite correctly that it must originally have stood upright. Two small stones, known as the 'Station Stones', and two low mounds, the 'North and South Barrows' lie close to the inner edge of the bank. But within the centre of the enclosure lie what to most people symbolise Stonehenge, the ruins of the great stone building.

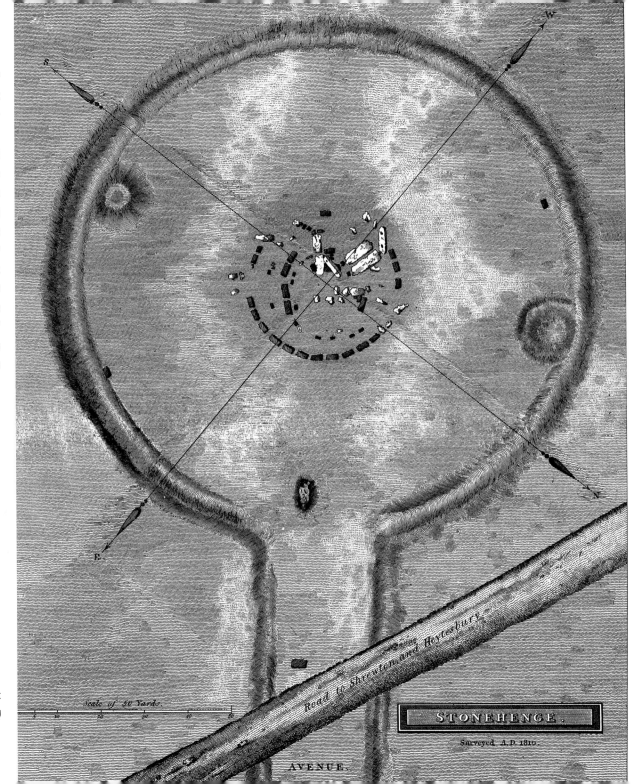

Ground Plan of Stonehenge from Colt Hoare's Ancient History of Wiltshire *(1811)*

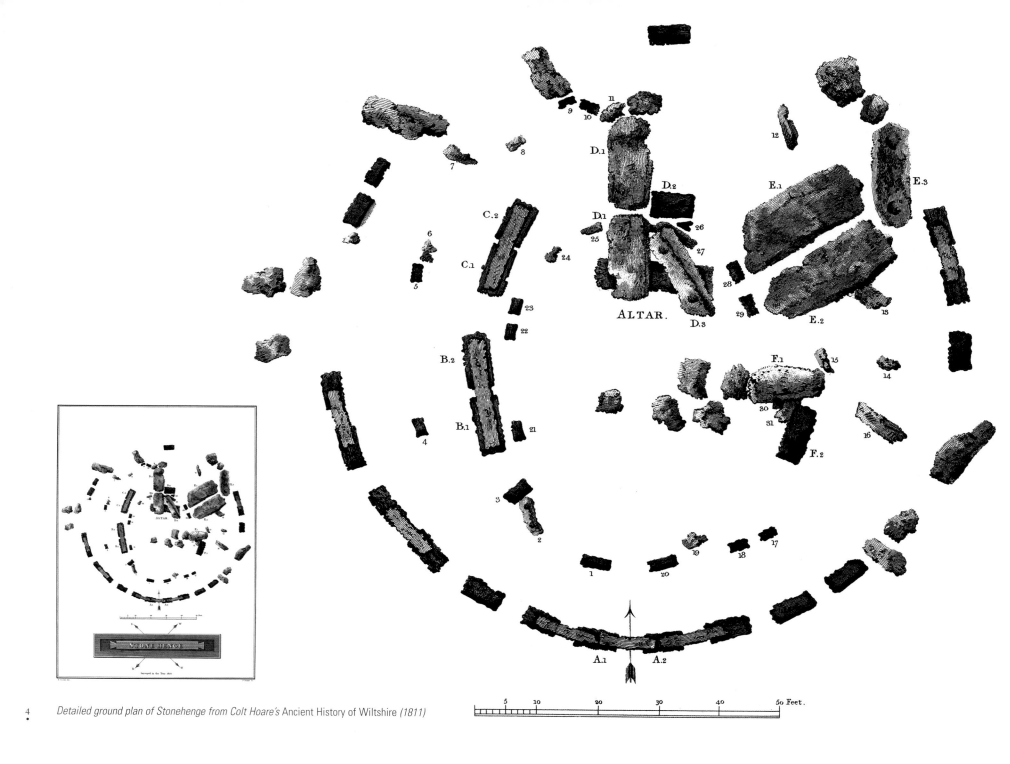

ALTAR.

STONEHENGE

5 10 20 30 40 50 Feet.

4
• *Detailed ground plan of Stonehenge from Colt Hoare's* Ancient History of Wiltshire *(1811)*

Crocker also drew a more detailed ground plan of the stone settings conveniently distinguishing those that were standing from those that had fallen (darker shaded). Hoare, as many had done before, recognised that Stonehenge was basically symmetrical, 'this temple consists of two circles and two ovals', and that there were different types of stone employed in its construction. There is an outer circle of what seems originally to have been thirty large carefully shaped uprights, still capped in places with horizontal lintels, linked end to end. These lintels, in their original form, might have formed a continuous circle of stone suspended high above the ground. The most complete section of this outer circle, where three linked lintels are still in place, lies opposite the entrance. Colt Hoare recognised the stones in this circle as being the same type of material as the Heel Stone and the Slaughter Stone, calling them 'sarsen stones'. He describes them in geological terms as 'a fine grained species of siliceous sandstone', a sandstone in which the grains of sand have been bound together with silica, the main component of flint. This explains the hardness of this type of stone. He also correctly suggests that they might have come from the Wiltshire downs some distance to the north near the great stone circle of Avebury.

1997, The Stonehenge Avenue from the north-east
(NMR SU1242/298 15041/25)

1987, The Heel Stone is a large, unworked sarsen nearly 5m high, surrounded by a circular ditch that lies immediately adjacent to the line of the A344. It leans towards the other stones, although originally was presumably upright. Its name comes from an ancient legend, of a friar who interrupted the devil as he was building Stonehenge. The devil in a rage threw a stone, hitting the unfortunate friar on the heel. The stone stayed where it fell, known from that day on as the 'Friars Heel', or more simply, the Heel Stone. (NMR 87/1252 P 45840)

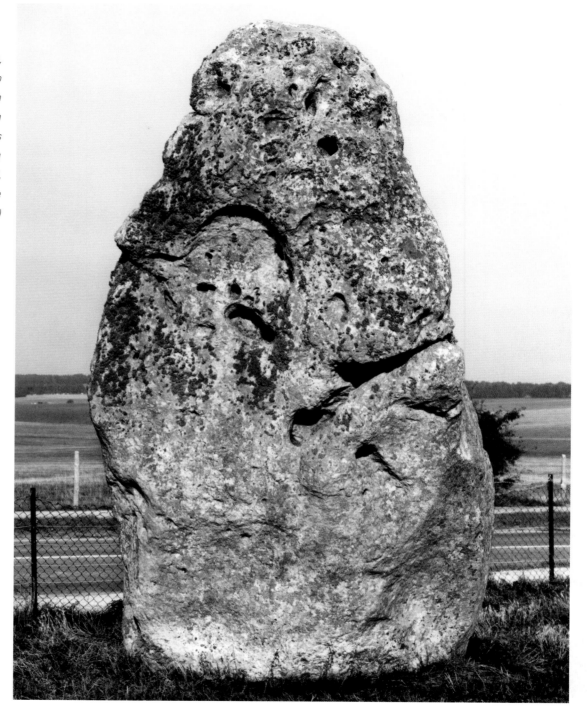

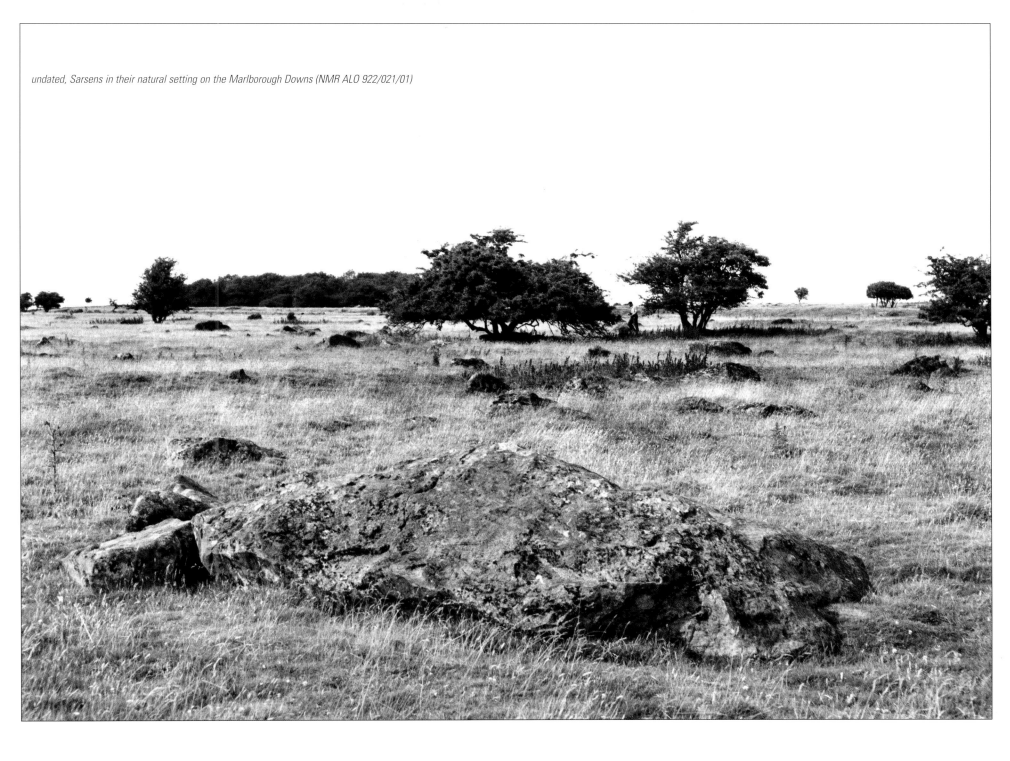

undated, Sarsens in their natural setting on the Marlborough Downs (NMR ALO 922/021/01)

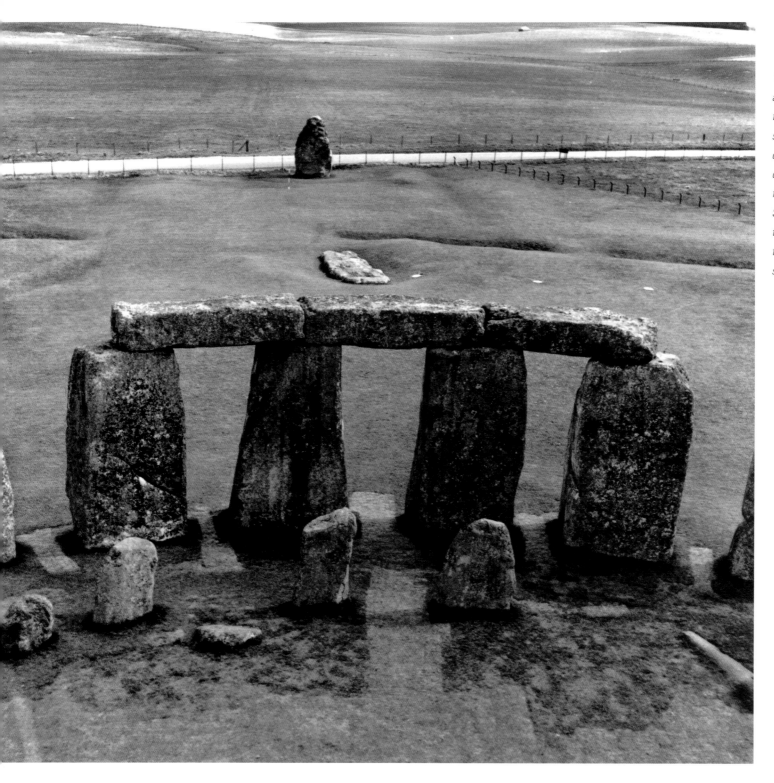

1958, The view looking north-east along the main axis of Stonehenge. Taken from high in the stones, the image is dominated by the best preserved section of the sarsen circle with its linked and curved lintels. The sarsen uprights dwarf the stones of the bluestone circle, which can be seen in the foreground. Beyond these circles the Slaughter Stone lies recumbent in the grass and beyond that, the entrance to the earthwork enclosure leading out to the Avenue. The massive bulk of the Heel Stone stands alone by the side of the A344 (NMR 11/12)

Inside this outer circle lie the remains of another. This one might originally have comprised sixty stones, much smaller than the sarsens and largely unshaped natural pillars. Colt Hoare describes their geology in great detail, using terms such as 'quartz, feldspar, chlorite and hornblende', but leaving it up to Cunnington to suggest that they might have come from 'some part of Devonshire or Cornwall' as there were no stones like this anywhere nearer. These are the famous 'bluestones', their distinctive colouring now masked beneath lichen.

Then comes the grandest and most impressive part of the whole structure, the 'cell or sanctum' according to Hoare, an open-ended oval or horseshoe of five great sarsen 'trilithons'. The term 'trilithon' was coined by William Stukelely, from the Greek for 'three stones', as this is exactly what they are. Each originally consisted of two massive uprights capped with a huge lintel but by 1810, when Crocker drew up his plans, only the two on the south-east side of this setting still stood intact. The last recorded fall had taken place only thirteen years earlier. This was of a complete trilithon (its stones numbered E1, E2 And E3 on Crocker's plan) and took place on the 3 January 1797, apparently as the result of deep snow followed by a very rapid thaw.

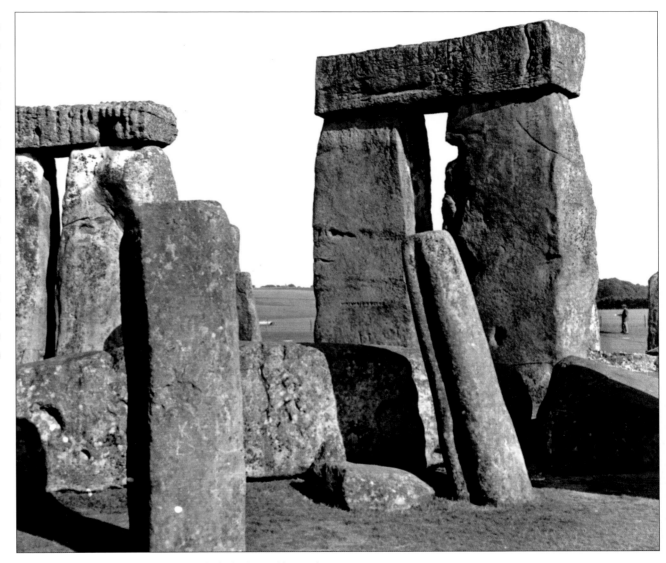

1954, Stonehenge, interior view facing west. In the background is one of the two trilithons that still stood at this time. In the foreground, in front of the wreckage of the tallest trilithon, stands Stone 68, the most elegant of the finely-worked bluestones of the inner horseshoe (NMR 1404 P 51292)

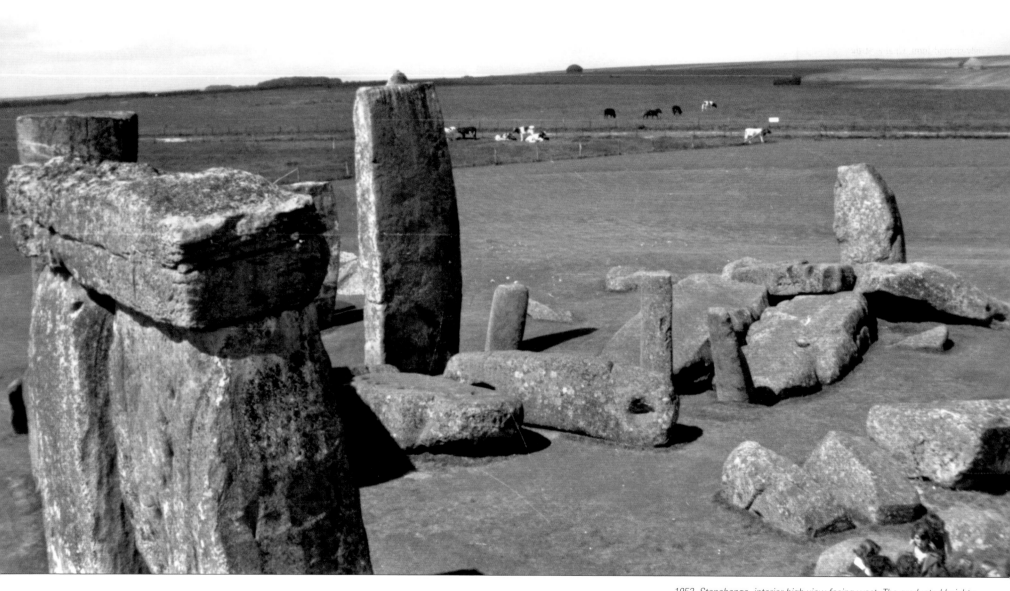

1953, Stonehenge, interior high view facing west. The graduated heights of the sarsen trilithons can be seen in this photograph, rising to what was the tallest at the closed end of the horseshoe. Of this, only one upright still stands. At its base lies the massive lintel (NMR 1.22/23 P51439)

Inside, and mirroring the shape formed by the sarsen trilithons, is a horseshoe of nineteen of the smaller stones, including some of a very elegant and finely-shaped form. Finally, at the closed end of this inner setting of bluestones, lies the Altar Stone, a large slab unlike any of the others and which now lies half buried beneath the fallen upright and lintel of one of the collapsed trilithons. To Cunnington, the bluestone horseshoe contained more of the 'inferior stones'. Colt Hoare even described them as 'unmeaning pigmy pillars of granite' and they both felt that they were later additions to Stonehenge when the builders had run out of suitable, local building material of a decent size and were forced to look farther afield.

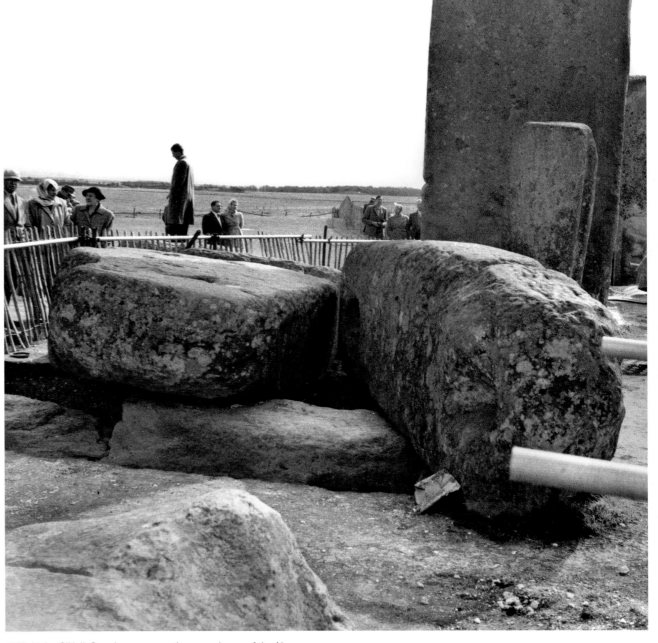

1958, Helen O'Neil: Stonehenge, excavations reveal more of the Altar Stone, a slab of sandstone from South Wales, embedded in the ground under the ruins of the tallest sarsen trilithon (NMR 5783)

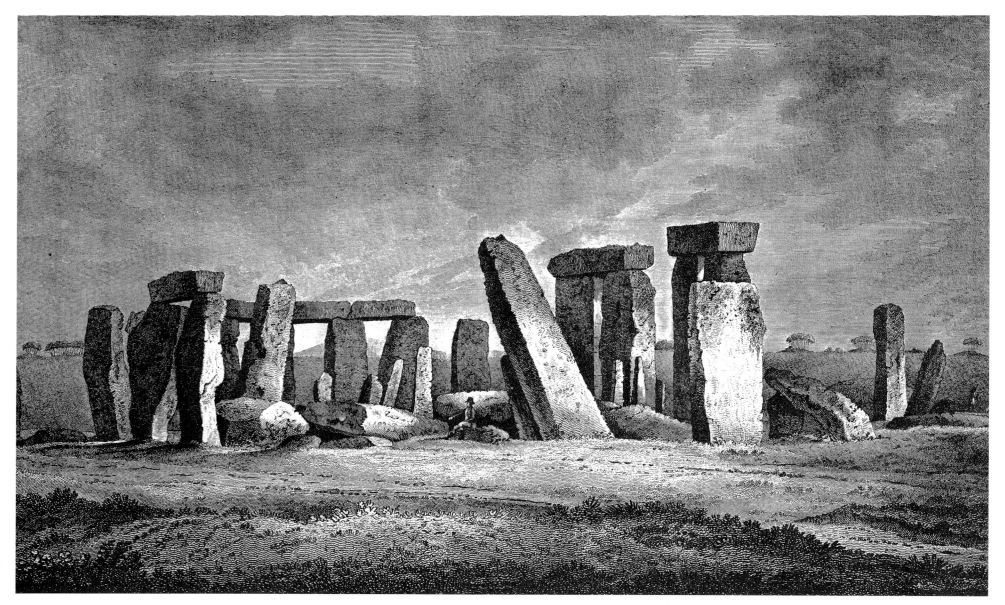

West View of Stonehenge from Colt Hoare's Ancient History of Wiltshire *(1811)*

Apart from a slight exaggeration of scale, as represented by the tiny figure seated on one of the recumbent stones, Philip Crocker's view of Stonehenge from the West is surprisingly true to life. The Old and New King Barrows, sporting the crop of trees that stopped Cunnington digging, leaving them as the only intact group of barrows in the area, can be seen on the horizon. On the far right of the view is the main London to Exeter road, now the A303. This view shows the outer sarsen circle, the two surviving trilithons and clearly emphasises the contrast in size between these and the 'pigmy pillars of granite'. The figure in the centre is seated below the alarmingly leaning upright of the tallest of the trilithons and appears to be pointing at one of the recumbent uprights of the trilithon that had fallen only a few years earlier in 1797.

This then is the visible structure of Stonehenge, the bare bones that continue to excite the curiosity of visitors today. They certainly excited the curiosity of Colt Hoare and Cunnington who, like many before, were tempted to dig.

Cunnington apparently 'dug with a stick' beneath the trilithon that fell in 1797. He found little to excite him then and even when he returned to investigate Stonehenge in a more organised way, he was again disappointed. In contrast to the wonderful finds from the surrounding barrows, Colt Hoare reported that 'no important discoveries have been made', no doubt singularly unimpressed by the 'heads and horns of deer… the coarse half-baked pottery' and the 'charred wood' that were their only finds. Their investigations yielded nothing that helped them to understand the date and purpose of Stonehenge. No wonder they preferred digging barrows and no wonder that when Colt Hoare wrote 'Ancient Wiltshire' he ended the section on Stonehenge with the following words:

HOW GRAND, HOW WONDERFUL, HOW INCOMPREHENSIBLE!

The First Photographs: 1853–1900

Stonehenge clearly has its 'good side' favoured by both artists and photographers and it is that same view of the stones engraved by Philip Crocker that takes us into the age of photography. The year is 1853, forty-two years after the publication of Crocker's engraving in Ancient Wiltshire. Queen Victoria has been on the throne for sixteen years, the ruler of an Empire that spanned the globe and the photograph itself comes from the personal album of her beloved husband, Prince Albert. It is two years since the Great Exhibition, a celebration of British commerce, power and invention and photography is still in its infancy.

Although the first permanent image, a 'heliograph' was produced by Nicéphoré Niépcé in 1826, it was far from practical, requiring an exposure time of nearly eight hours. In the 1830s the first workable system of photography was evolved by the French pioneer Daguerre and, after years of experimentation, was released to the public in 1839. The 'Daguerreotype' produced a detailed image but was very expensive, each print costing perhaps as much as a guinea (£1.05). Despite the added disadvantage that only a single image could be produced, the French State purchased the rights to Daguerre's process and made it available free of charge.

In England in 1839, W H Fox Talbot, of Lacock in Wiltshire, presented papers detailing his own photographic process to the Royal Institution and to the Royal Society. It was also in this year that the term 'photography' was first used, although 'photographer' did not appear until 1847. Fox Talbot's 'calotype' (later 'Talbotype') was a negative–positive process, with the major advantage that multiple prints could be produced from a single negative. But despite this, and a reduction in exposure times down to as little as five minutes, this new medium was slow to catch on in England. This failure was mainly due to Fox Talbot who, for a decade, made photography difficult for others by patenting his every invention and improvement. Licenses were only granted to a select few provincial operators.

The problems caused by Fox Talbot's patent restrictions finally came to a head in the 1850s. At the Great Exhibition of 1851, a display of photographs showed the people of Britain just what they had been missing. In the same year Frederick Scott Archer announced his Collodion process, far more practical, reducing exposure times down to two or three seconds and the cost of a photograph down to a shilling (5p). But even more important, Archer's process was free of restrictions. Within the next two years Fox Talbot was forced to relax many of his patent claims, and photography was at last able to take off. As demand rose there was an inevitable decrease in the price of equipment and materials while the number of photographic establishments rose from a handful in the mid 1840s, to 66 in 1855 and, two years after that, to more than 150.

At the same time that photography was emerging as a practical and affordable method of capturing images, perceptions of the past were also changing. In 1848, in a book entitled *A Guide to Northern Antiquities*, the Danish scholar C J Thomsen had outlined a system for placing ancient artefacts in an order that reflected time. Prehistory, the time before written history, was now divided into successive ages of stone, bronze and, most recent, of iron. For the first time sense could be made of the accumulated mass of ancient finds that filled the museums of Europe. Six years later Charles Darwin published *On the Origin of Species*, explaining how the concept of evolution was the best theory for the origin and development of all living things. Stonehenge could now be seen in a new light.

Given Stonehenge's enduring popularity, a symbol of British achievement in an age of British triumphalism, it is hardly surprising that the first known photograph of Stonehenge dates from 1853, the year of liberation for the new art of photography. The photograph, a calotype, was taken by William Russell Sedgefield of Devizes, at first an amateur, later a professional photographer. The view is not identical to Crockers's, drawn over forty years earlier, but the setting has changed little. On the near horizon the trees that cover the King Barrows have grown and within the stones the small, seated figure has been replaced by a carriage.

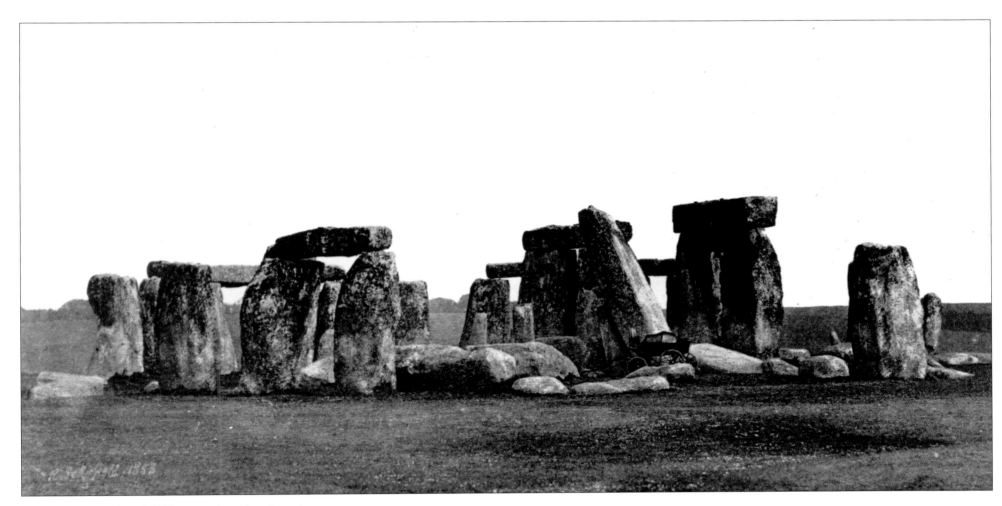

1853, William Russell Sedgefield: The stones viewed from the west

(Royal Collection Trust / © Her Majesty Queen Elizabeth II 2017)

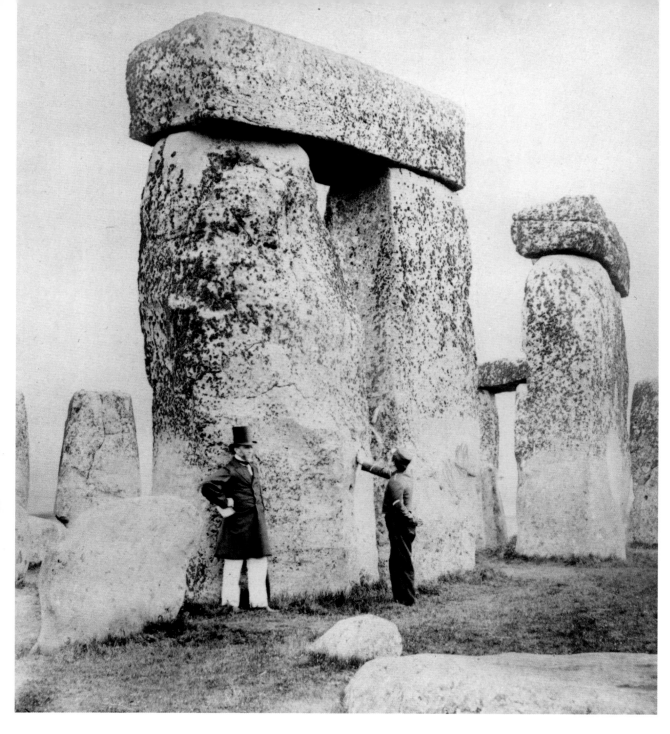

The realisation that pen and brush could now be replaced by an instant chemical process did not endear the new process to many artists at this time. But there were soon those whose interest was not artistic, rather the achievement of a factual, objective record. One of these was Colonel Sir Henry James, the Director General of the Ordnance Survey, who, in 1867, published *Plans and Photographs of Stonehenge and of Turusachan in the Island of Lewis with notes relating to the Druids and sketches of cromlechs in Ireland*. In this rather lengthily titled volume is a series of photographs, taken by the Ordnance Survey, showing the interior of Stonehenge. Many of them feature an imposing-looking gentleman in a top hat, presumably Sir Henry himself, accompanied by a bored-looking minion. Accompanying this scientific record are Sir Henry's observations, many of which show his thinking to be firmly fixed in a more antiquarian mould. The bluestones were 'probably monumental stones to the memory of a chieftain and priests, afterwards erected in the temple' while 'the construction of this grand work has traditionally, and I think rightly, been attributed to the Druids'.

1867, Colonel Sir Henry James, Ordnance Survey stands at the rear of one of the surviving trilithons on the south east side of the sarsen horseshoe. This trilithon possesses Stonehenge's most elegant and finely-shaped lintel (NMR BB 95/50010)

Looking over the wreckage of the trilithon that fell in 1797, the figures stand by the base of Stonehenge's tallest stone. This is the sole standing upright of the Great Trilithon, the tallest of the five that stood at the south-west end of the horseshoe. This stone, weighing more than 40 tons, now leans at an alarming angle and rests on a finely shaped bluestone pillar, the tallest and most elegant stone in the bluestone horseshoe.

The Ordnance Survey photographs were the exception to the rule. For the most part the views that exist of Stonehenge in the second half of the 19th century tend to concentrate on the central cluster of stones, a romantic ruin in a downland setting. Some stones still stand upright, others have fallen or lean drunkenly and although many of these images are undated there is one strong visual clue that fixes them firmly within Victoria's reign. In all of them Stonehenge's tallest single stone, the one surviving upright of the Great Trilithon, leans inwards at an alarming angle.

But in 1901, in the 64th and final year of Queen Victoria's reign, this stone, by this time known as number 56, was straightened. This was not only a turning point in the history of Stonehenge, marking the change from decay to repair, but it also helps to date any early photographs. Those that show the stone leaning must date to before 1901, if it is upright then they date to the years after 1901.

c 1875, Richard Phillimore: Stonehenge, inside the stones from the north-west (NMR BB 86/5294)

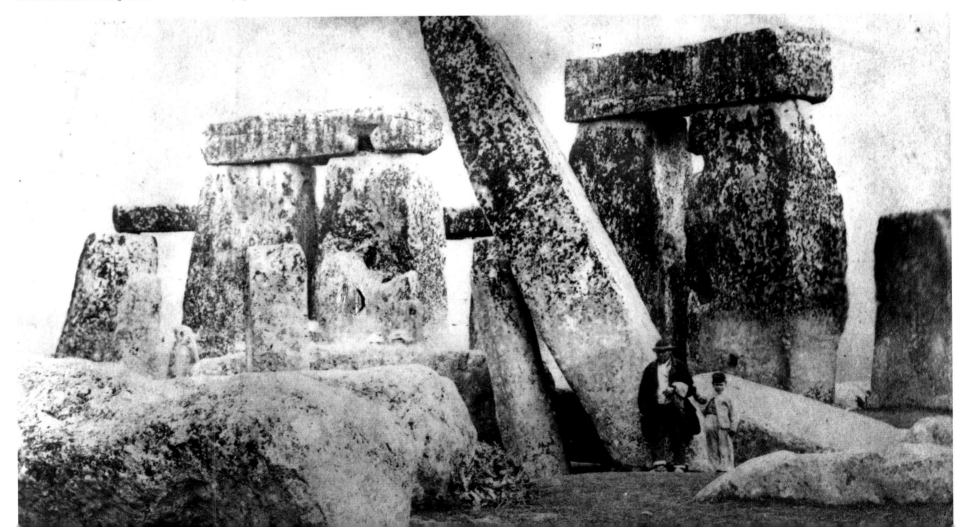

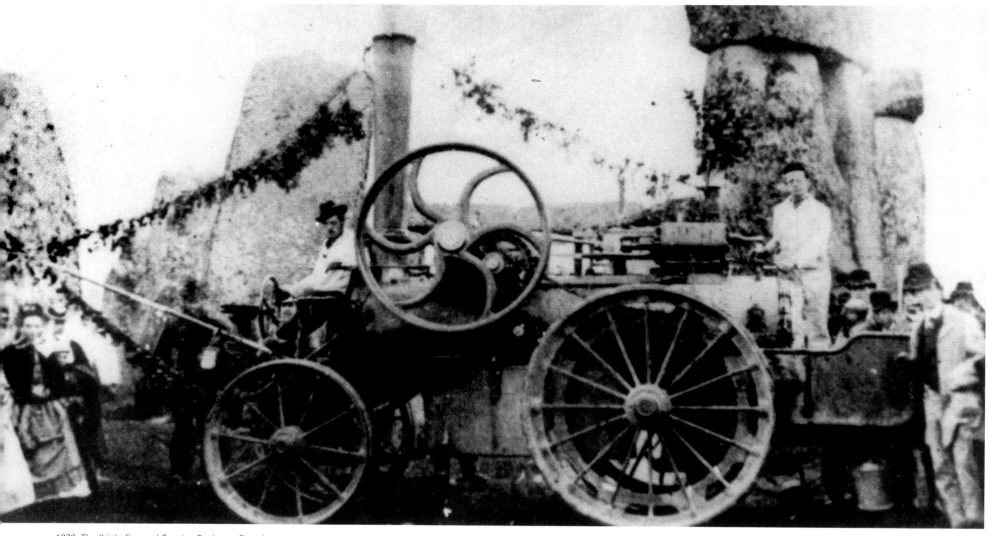

1878, The 'Little Express' Traction Engine at Stonehenge

(Wiltshire Record Office P31593)

This photograph records a memorable excursion by the villagers of Market Lavington on Thursday May 29th 1878. Setting off at 7 am and paying 1/3d (approximately 6p) for the privilege, they travelled the 14 miles to Stonehenge behind the Little Express traction engine owned by their local brickwork owner and bandmaster Mr Edward Box. Mr Box stands at the rear of the engine; his son Herbert is at the forward controls. The trip was accomplished successfully, although the traction engine, the first in Wiltshire and with a top speed of approximately 4mph, would have taken all day to travel the 28 mile round trip.

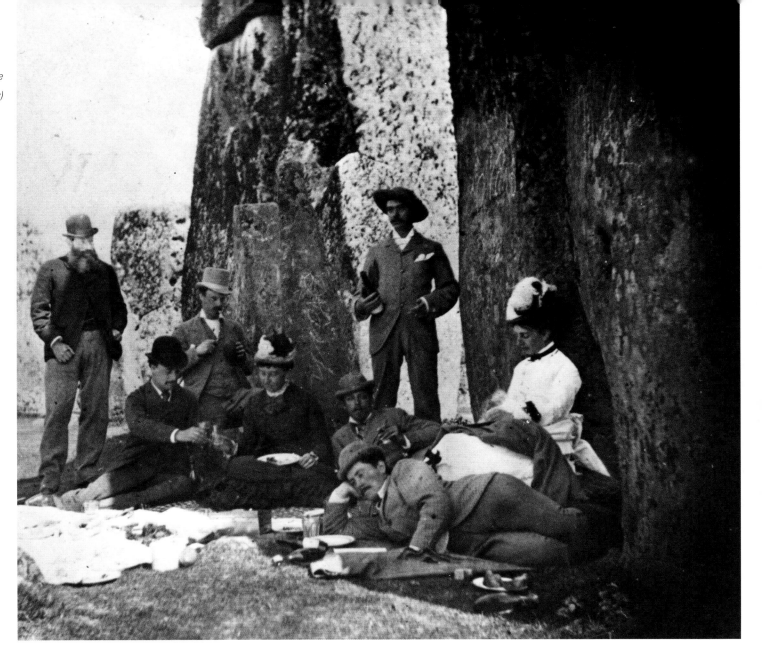

The royal connection with Stonehenge did not end with that first photograph of 1853. In about 1880, Prince Leopold, Queen Victoria's youngest son, enjoyed a picnic at the foot of a trilithon. Leopold, who died at the age of 31, is seated fourth from the right. The gentlemen for the most part look confidently at the camera, the ladies look suitably demure.

*c 1880, J L Lovibond: Stonehenge interior facing east
(NMR MPBW Photographs Collection)*

An unusual view, from low down and close to the centre of the stones. In 1877 the stones were all surveyed with great accuracy by the archaeologist Flinders Petrie who also introduced the numbering system that has been in use ever since. So the angled stone on the right of the photograph, now apparently leaning at an even more alarming angle, is now Stone 56. Beyond can be seen the two intact trilithons. In the foreground the figure sits on part of a trilithon that fell inwards, while the massive stone in the right-hand foreground is an upright of the one that fell outwards in 1797.

Many of those who wrote about Stonehenge in the 19th century lamented the collapse of so many of the stones, but acknowledged the details of construction that were afforded by the fallen stones. The lintels of the outer sarsen circle are jointed end to end by means of a vertical groove into which a corresponding vertical protruding 'tongue' was fitted. This is effectively a tongued and grooved joint of the type used to fit wooden boards together. The lintels are then jointed onto their uprights by means of mortice and tenon joints in which a hollow, the mortise hole, is pounded out of the underside of the lintels and fits over a corresponding knob or tenon worked onto the end of the upright. This too is carpentry in stone, but stone that is as hard as granite, and without the assistance of metal tools.

There are further subtleties in the sarsen circle. Each upright tapers slightly from its base and the lintels are not straight but have inner and outer edges that curve gently to follow the line of the circle.

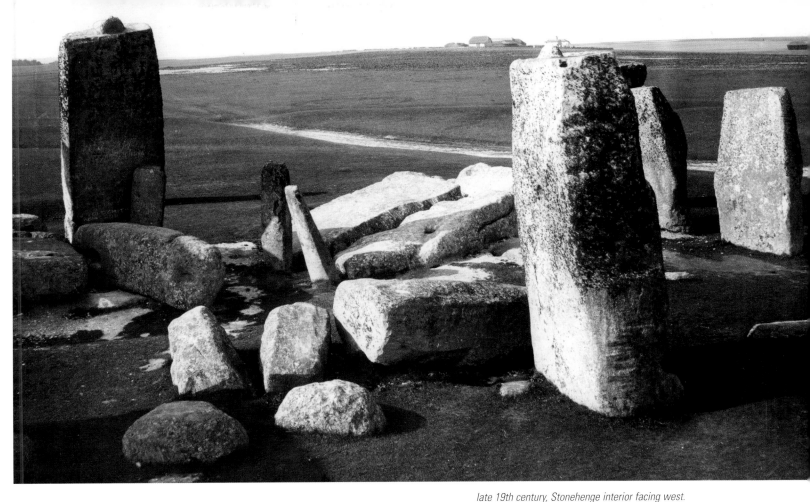

late 19th century, Stonehenge interior facing west.

Probably taken from the top of the outer circle

(NMR MPBW Photographs Collection)

This view emphasises the ruinous state of Stonehenge in the late 19th century. Of the three trilithons that should be standing in this view only two uprights out of six remain. Stones have fallen inwards and outwards, some broke as they fell and a large section of the outer sarsen circle has disappeared. On the horizon farm buildings have appeared, on the site of what would later become the Stonehenge Aerodrome. Animals appear to be burrowing, throwing out chalk that has been used by visitors, including J Goldsmith of Abingdon, to inscribe the stones.

The same mortice and tenon joints that were used in the outer circle were used to assemble the components of the trilithons. Pronounced tenons can be seen on uprights that have lost their lintels while the fallen lintel of the Great Trilithon shows correspondingly huge mortice holes.

Within the sarsen horseshoe the individual trilithons are graded in height. The two at the open end of the horseshoe are the lowest, the middle pair is higher and the tallest was the Great Trilithon that stood at the south west end of this arrangement. This was a case of available raw material not quite matching up to prehistoric ambition as, in order to achieve the required height, one of the uprights had to be set insufficiently deep into the chalk. This, ultimately, was the cause of its collapse.

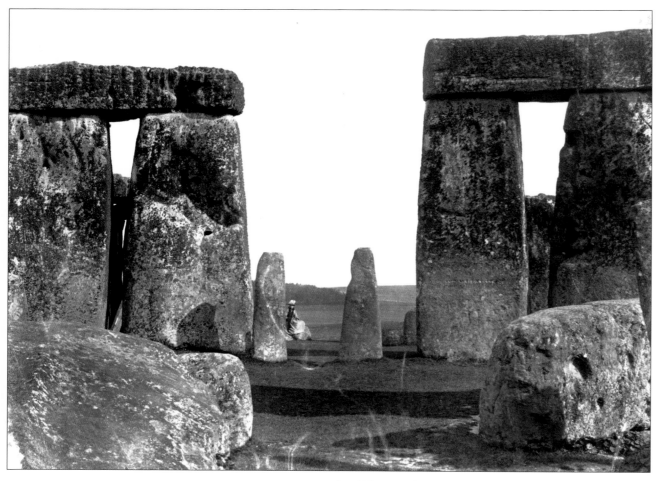

late 19th century, Stonehenge interior facing south east
(NMR MPBW Photographs Collection)

This view shows the east side of the sarsen horseshoe, where two trilthons survive intact, elegantly framing two bluestones of the innermost setting. The lady in the background is seated on a fragment of the sarsen circle. The trilithon on the right is composed of perhaps the most finely shaped stones in the entire structure, and their smooth surfaces have tempted graffiti artists both ancient and comparatively modern. On the left-hand upright, Stone 53, about a quarter the way up, someone has neatly carved their name. The individual letters, although now much eroded, are finely cut, obviously using a hammer and chisel and implying a certain premeditation.

The stones have been carved in much earlier times too, however. Look carefully on the same view, just below the name, and the clear outlines of axes and what may be a dagger can be seen. These are genuine prehistoric carvings, decoration added to the stones at the time that Stonehenge was newly built and then forgotten for thousands of years. In fact, despite being clearly visible on photographs dating back to the 19th century, they were not 'discovered' until 1953.

The importance of Stonehenge was formally recognised in 1882 when it appeared on the first Schedule of English Monuments. This was the list of sites, defined as being of national importance, that were supposed to be protected by the newly-introduced Ancient Monuments Act. In reality this act had little effect on Stonehenge. Its owner, Sir Edmund Antrobus, declined to accept any help or, as he saw it, government interference, and continued to run Stonehenge in his own way. Stones were propped up when they appeared to become unstable, but otherwise little was done.

In the 1890s concern grew about the state of Stonehenge. On September 26th 1893 it was visited by General Pitt Rivers, Inspector of Ancient Monuments in Great Britain. His official report, submitted on October 2nd, paints a fascinating picture. He scotches the rumour that stones had been broken up and taken away, but notes that they are still having names scratched on them. Rats, mice and rabbits, attracted by scraps of food left by picnickers, burrow underneath the stones, threatening their stability.

On the subject of the overall stability of Stonehenge, Pitt Rivers is greatly concerned. 'Notwithstanding what has been said to the contrary, it is quite certain that sooner or later, and more probably soon than later, most of the stones will fall through natural causes. It does not require to be an engineer or an archaeologist, but merely the exercise of a little common sense to see that some of the stones are in process of slowly falling over.'

His solution? '… is to have the inclining stones brought up to the perpendicular, and the foundations should then be set in cement concrete or masonry. This would be very expensive, but it would secure the monument to posterity.'

Pitt Rivers also reports on the day-to-day running of Stonehenge, noting that 'The stones are to some extent in the charge of a photographer, who lives at Shrewton. …, he lives by selling photographs to visitors and this may to some extent perhaps, disqualify him from keeping them in proper order…'

This photographer was William Judd, who was paid £10 a year by the owner of Stonehenge, Sir Edmund Antrobus, and whose presence at the stones was largely governed by the potential number of visitors. Pitt Rivers notes that he was there not so frequently in winter.

Towards the end of the 19th century it was difficult to take a photograph of Stonehenge without including the caravan belonging to Mr Judd, the Shrewton photographer and unofficial custodian. It is not known whether or not Mr Judd would disappear into his mobile darkroom and produce instant snapshots for his customers.

1890s, View of Stonehenge from west with Mr Judd's caravan (Wiltshire Record Office P2202)

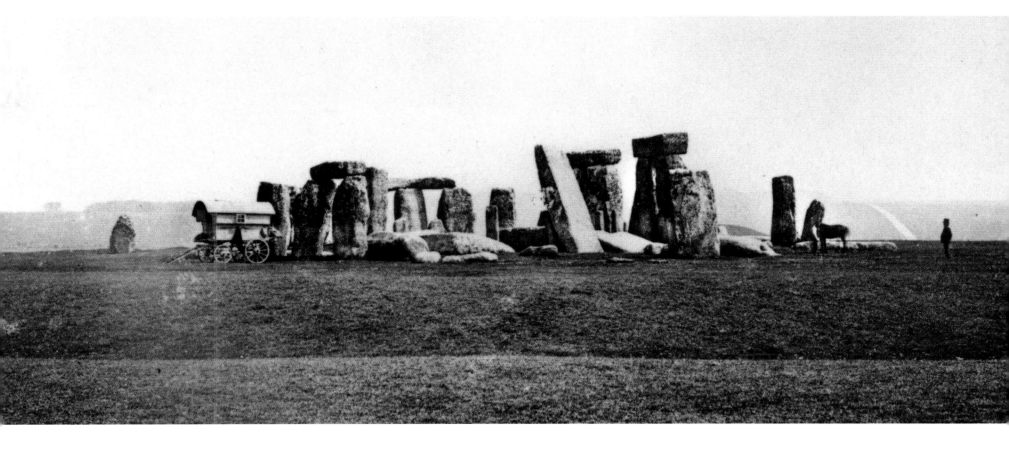

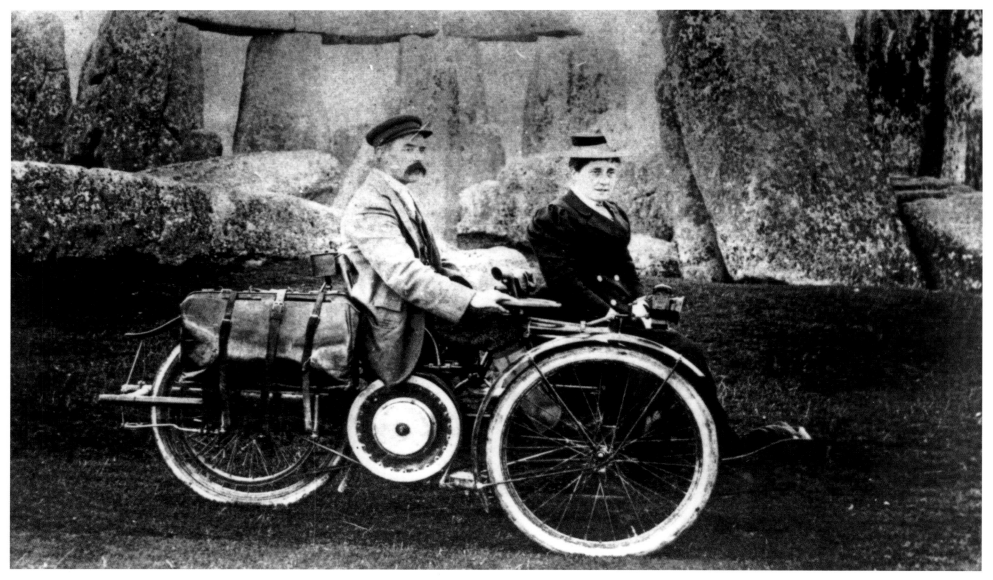

c 1900, Mr and Mrs George Burt of Burcombe, Wiltshire at Stonehenge
This photograph must date to before 1901, as Stone 56 still inclines in the
background. The vehicle, a Leon Bolle Tricar, is the first hint of the impact
that motor transport would have on Stonehenge and it's surroundings
throughout the following century. (Wiltshire Record Office P16227)

On the last day of the 19th century, 31 December 1900, seven years after Pitt Rivers's prophetic report on the state of Stonehenge, his prediction came true. A sarsen upright on the western side of the outer circle, together with its lintel, blew down in a gale. The lintel broke in half.

This was the event that changed Stonehenge, that signified the move from decay to restoration. The new century would bring a new Stonehenge.

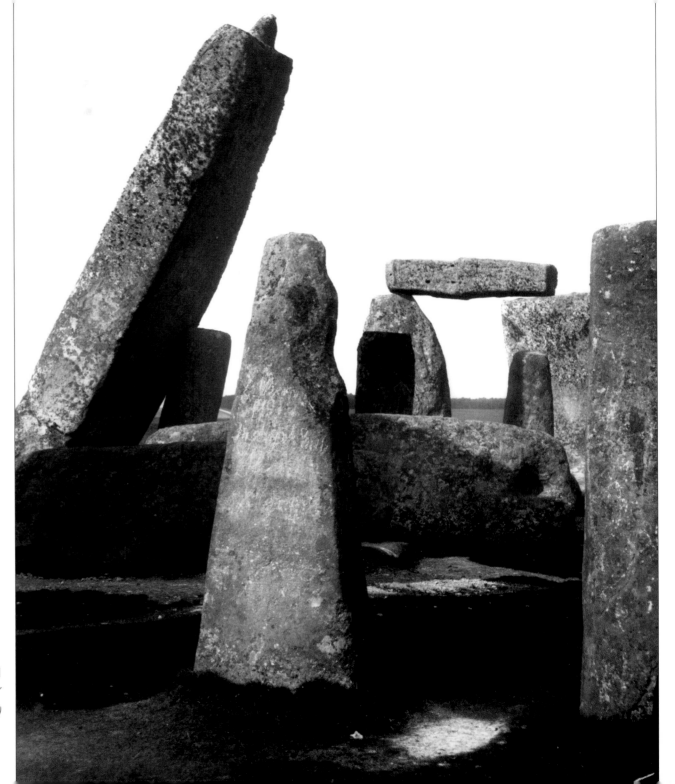

1881, 'A view looking N. W. showing stone and lintol [sic] *since fallen and leaning stone of Great Trilithon adjusted in 1901' (NMR ALO 913/011/01)*

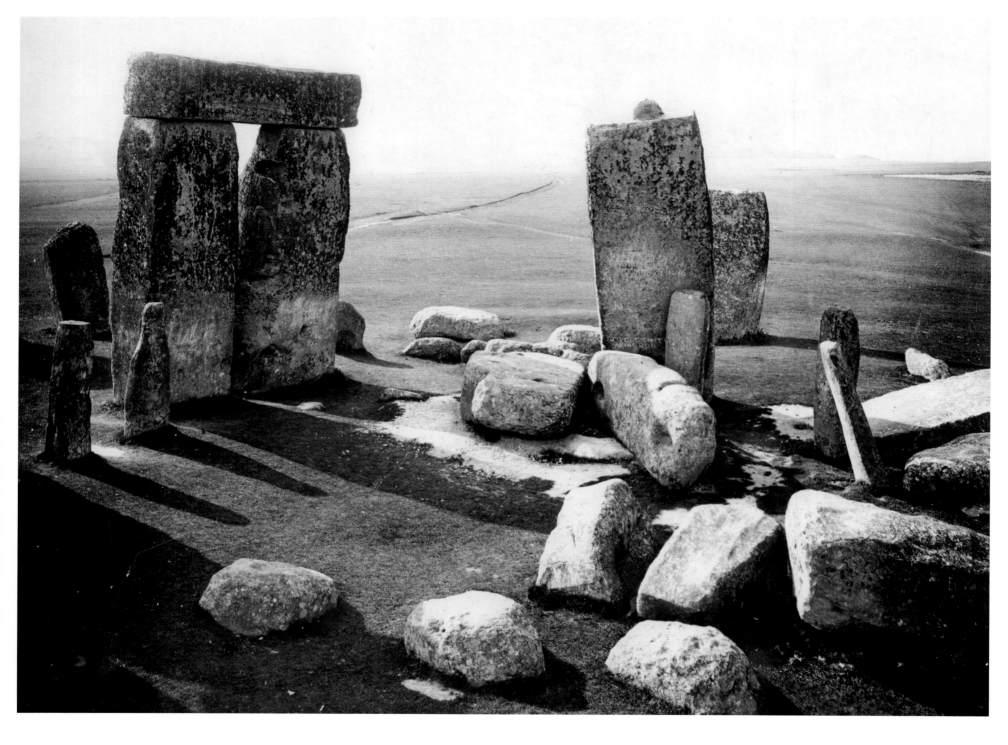

Stonehenge entered the 20th century as a much loved, but crumbling ruin. The refusal by its owner, Sir Edmund Antrobus, of any help in running his monument, was a mixed blessing. On one hand his obstinacy protected Stonehenge from what would have undoubtedly been excavation and restoration on a huge and destructive scale. On the other hand, structurally Stonehenge was in a terrible state.

Change started almost immediately. The collapse that took place in December 1900 had raised questions about the safety and stability of the whole monument, but Sir Edmund was also well aware of the commercial value of his property. He decided to fence off Stonehenge and, for the first time, to charge admission.

Fencing off Stonehenge was not a popular move, and not just within the local community. Where restoration was concerned, opinion was sharply divided. Some suggested that Stonehenge should simply be allowed to decay and fall into ruin. Others favoured complete restoration, with every stone that could possibly be reconstructed set in a solid bed of concrete neatly topped off with asphalt. Work started in the autumn of 1901 and fortunately a middle course was steered, with the emphasis on a more gentle approach. For many years the angle of lean of Stone 56, the surviving pillar of the great trilithon, had gradually increased until, at sixty degrees, it threatened to topple completely and carry with it the elegant bluestone on which it rested. It was decided that this stone should be pulled upright. The work was entrusted to the Wiltshire architect Mr Detmar Blow, with the necessary archaeological investigation to be carried out by Professor William Gowland of the School of Mines at South Kensington.

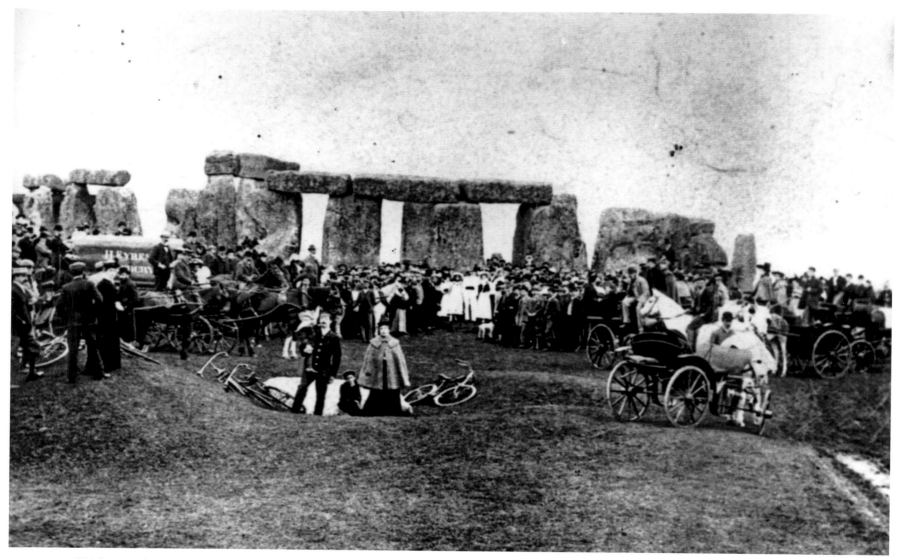

1901, Protest at Stonehenge (Wiltshire Record Office P8425)

To the annoyance of many, Stonehenge was fenced for the first time in May 1901. This was a very profitable arrangement for Sir Edmund Antrobus as, within five months, 3,770 visitors had paid their shilling entrance fee.

This photograph, taken in 1901, shows that the residents of Amesbury were not happy about this new arrangement, and particularly about being charged for something that they felt was their ancient and inalienable right. They have gathered in mass protest, arriving on foot, by carriage and bicycle and even apparently in the wagon belonging to the local carrier, Mr Eyres. This can just be seen buried in the crowd. The protest failed though. The fence and the admission charge stayed, to be followed shortly by a turnstile and a stall for refreshments.

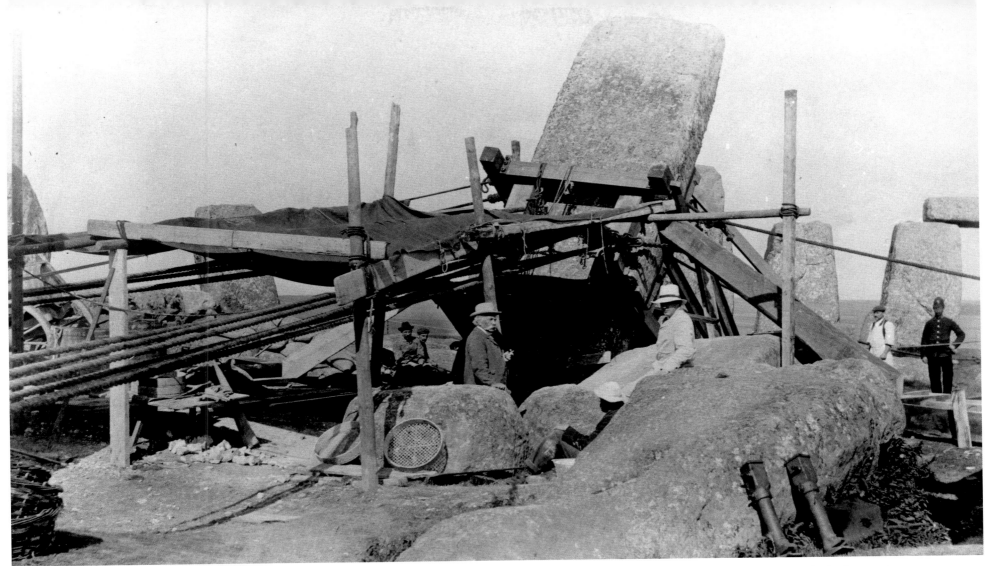

1901, The beginning of Professor Gowland's excavations around Stone 56 (Wiltshire Heritage Museum)

Gowland, the gentleman with the impressive moustache standing by the base of the stone, may seem like an odd choice to carry out such a delicate and prestigious task, as he was not an archaeologist. An expert in early metal working, Stonehenge was his first attempt at excavation.

Sensibly, he resisted the temptation to carry out a large excavation and only opened up the area around the base of the stone that the engineers would disturb in carrying out their work.

The first task was to secure the stone in a stout crib of timber, the framework in which it could be gradually winched upright as work progressed. Only then could Gowland start to excavate, digging the hole in small sections, each of which had to be filled with concrete before the next could be dug.

Site security was under the control of a policeman employed by Sir Edmund Antrobus.

Despite not being a professional archaeologist, Gowland, here seen supervising his workmen, set new standards in excavation. He might not have done any actual digging himself, but every shovelful of soil was removed under his close supervision. Unlike many contemporary archaeologists, who tended to supervise from afar, he was on site both before and after any excavation took place in order not to miss the smallest detail.

The excavation methods that were used were very advanced. The photograph clearly shows the graduated rectangular wooden measuring frame in position around the edges of the hole. This enabled him to establish the location of every find to be planned with great precision.

Even more remarkable was that all the excavated material was sieved through meshes of one, half, quarter and one eighth of an inch so that even the tiniest find was recovered.

1901, Professor Gowland's team sieving by Stone 56
(Wiltshire Heritage Museum)

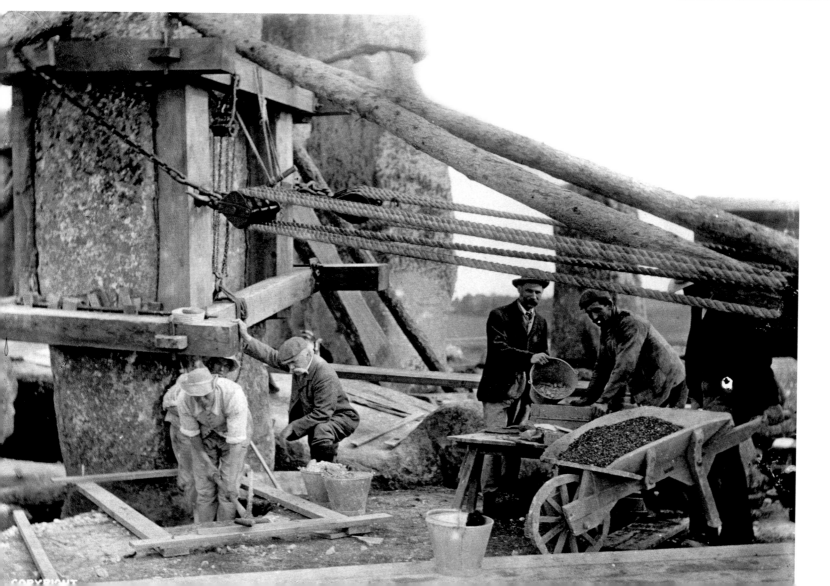

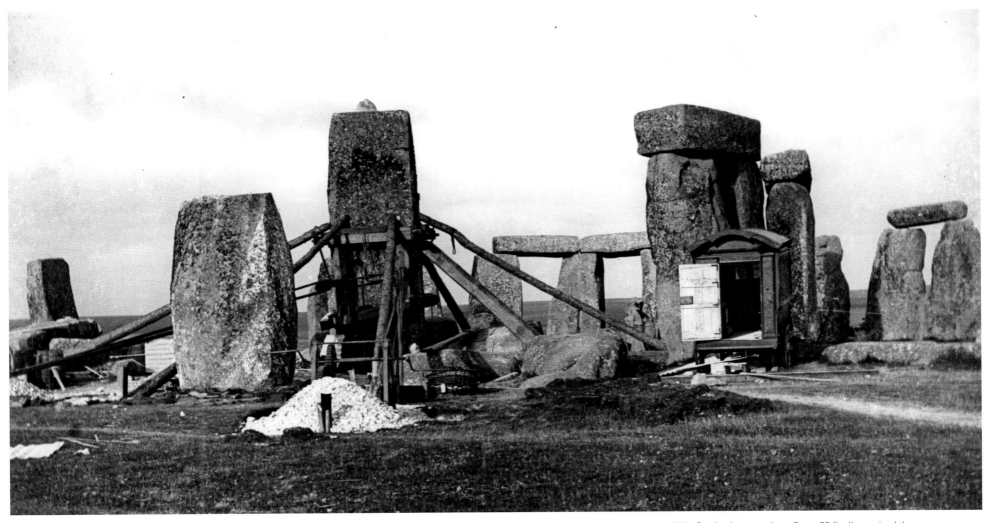

1901, Gowlands excavations, Stone 56 finally regained the vertical on 19 September 1901 (NMR AA80/6439)

The results of Gowlands' excavation were out of all proportion to their size. Stone 'mauls', balls some of which were the size of footballs, showed how the stones had been shaped, and he had found out how the holes in which they stood had been dug. The shape of the hole for Stone 56 demonstrated that it had been put up from the inside of the structure and he suggested that the bluestones and the sarsens were of much the same date. He also made a good guess about what that date was: 'during the latter part of the Neolithic age [the New Stone Age] or the period of transition from stone to bronze, and before that metal had passed into general practical use'. Gowland estimated that to be around 1800 BC, effectively banishing the Druids, a late Iron Age priesthood dating from at least 1,500 years later. Gowland considered Stonehenge to be a temple to worship the sun. As far as its origins were concerned he rejected all previous fanciful suggestions and was of the opinion that it was built by 'our rude forefathers'.

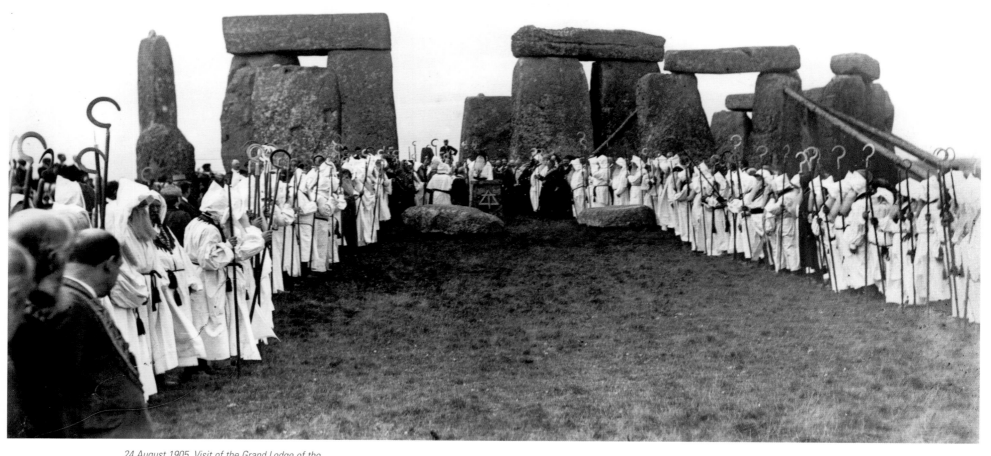

24 August 1905, Visit of the Grand Lodge of the Ancient Order of Druids (NMR BB67/429)

The mass initiation attended by nearly 1,000 modern-day Druids was conducted with elaborate ceremony but was reported in a far from favourable light in the following day's *Star*. To their reporter, possibly the one who was said to have bribed his way into the proceedings, they were conducted by a 'train load of sham druids' indulging in 'childish tomfoolery, of cotton-wool beards, calico nightshirts and tin insignia'. The article ended with a 'protest against the simple majesty of Stonehenge being invaded by these shoddy mysteries and sham antiques'.

This may have been the first 20th century Druid ceremony at Stonehenge, but it would certainly not be the last. Throughout the 20th century the photographs that most graphically chronicle the changing face of both Stonehenge and its surrounding landscape, are those taken from the air. This is the first recorded aerial photograph, and shows evidence both of visitors and of the effects of passing traffic in the tracks that criss-cross its fragile earthworks, white eroded chalk against a grassy background. The proximity of these tracks to the stones would prove contentious in later years.

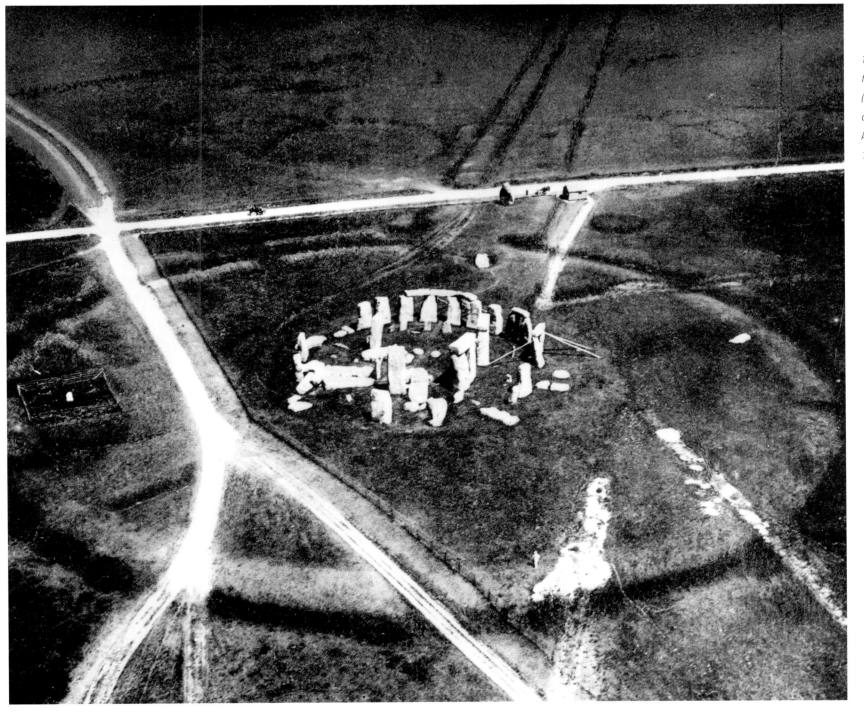

*1905, Stonehenge
from an Army balloon
(Society of Antiquaries
of London, from
Archaeologia, 60,
1907, pl LXIX)*

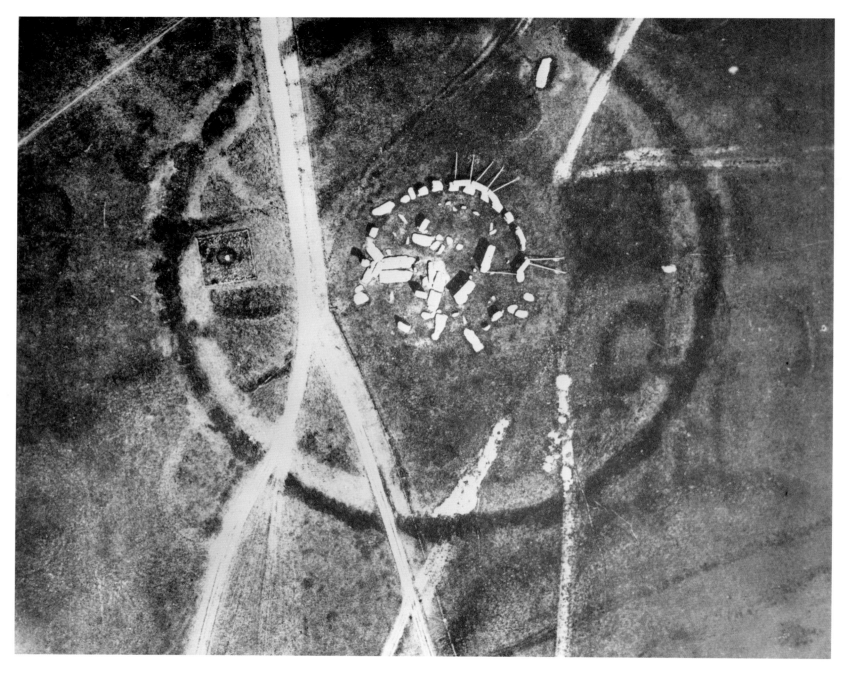

1 January 1906, Lieutenant P E Sharpe, RE: Stonehenge from a war balloon (NMR SU 1242/65 PHS11816/1)

Close up the photograph taken by Lieutenant Sharpe shows the ruinous state of the monument, the central jumble of fallen stones where only two of the five trilithons still stand and the evidence of continuing instability in the wooden props that hold up many of the surviving uprights of the outer circle.

34

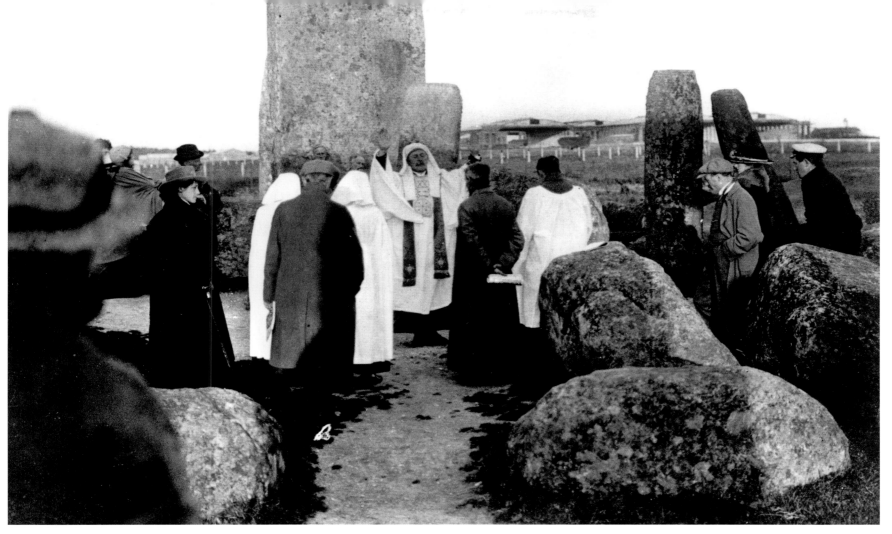

c *1920, A small gathering of Druids and visitors celebrate the summer solstice (Wiltshire Record Office P2201)*

In contrast to the mass Druidic visit of 1905 at a later date, a smaller and more select band gathered to celebrate the summer solstice under the direction of Dr George McGregor Reid, Chief Druid of the Church of the Universal Bond. By this time most summer solstices appear to have been accompanied by some sort of celebration, most of which have gone largely unrecorded. In the 1920s militants from the Church of the Universal Bond openly confronted the authorities over their rights not only to carry out ceremonies at Stonehenge but also to bury the ashes of their dead within the stones. They felt that they should be able to extend their celebration of the Summer Solstice almost indefinitely and the dispute over burial rights led to a growing backlog of the remains of recently departed Druids.

In this photograph it is the backdrop to the actual ceremony that is of interest. On the crest of the low rise to the west of Stonehenge are the buildings of the training aerodrome established for the Royal Flying Corps in 1917. According to rumours, widespread both in the local population and the military, there were serious proposals for the stones to be removed, as they were considered to present a hazard to low flying aircraft at times of poor visibility.

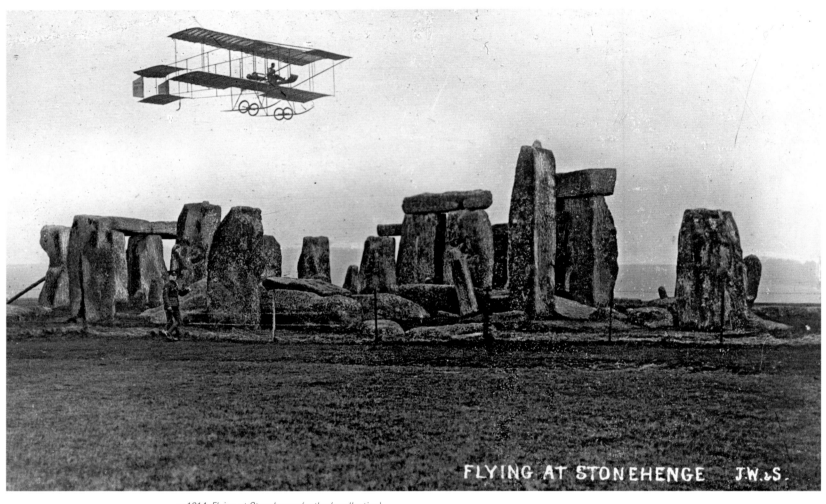

FLYING AT STONEHENGE J.W.&S.

c 1914, Flying at Stonehenge (author's collection)

The combination of an attraction like Stonehenge and the novelty of flying resulted in the production of many images for postcards with titles along the lines of 'Flying at Stonehenge'. This photograph, dating from about 1914, apparently shows a Bristol Boxkite soaring effortlessly above the stones. A clue that this may not be all that it seems comes from the crispness of the detail visible on the apparently moving aeroplane. It is in fact an early example of a composite image, with the plane superimposed on a photograph of Stonehenge. So, even at this time, the camera was capable of lying.

Even during the terrible years of the First World War there were those who voiced their concerns for Stonehenge and the potential damage that the military was inflicting. The tracks that were so clearly visible on the first aerial photograph and that ran so close to the stones, were further eroded by heavy military traffic. This photograph shows horses and gun carriages, but to these were now added lorries and even the first tanks.

There were also fears that the activities of the Royal Artillery, based close by to the north in Larkhill Camp, would cause damage to the stones themselves.

In 1916 a fresh crack was noted in one of the fallen stones and the custodian was reported to have little doubt of its cause… 'mine explosions on the Plain, near enough to shake his hut and dislodge objects from its shelves'.

On September 21st 1915, after the death of Sir Edmund Antrobus, Stonehenge was sold at auction to a local landowner, Mr Cecil Chubb. The price was £6,600. Three years later Chubb offered Stonehenge to the nation, who accepted the generous gift.

But what had they accepted?

1915, Canadian troops marching through Stonehenge (Imperial War Museum Q 53573)

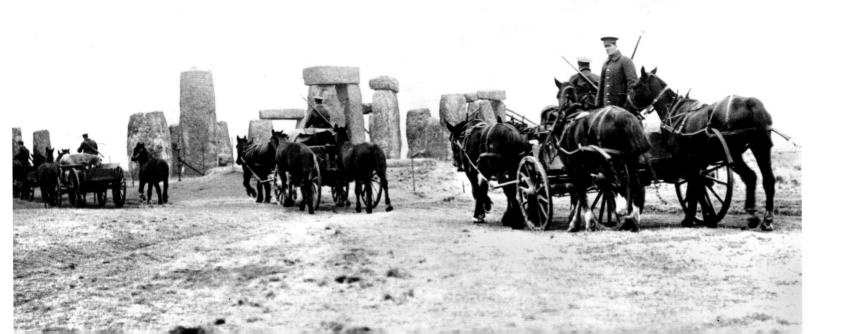

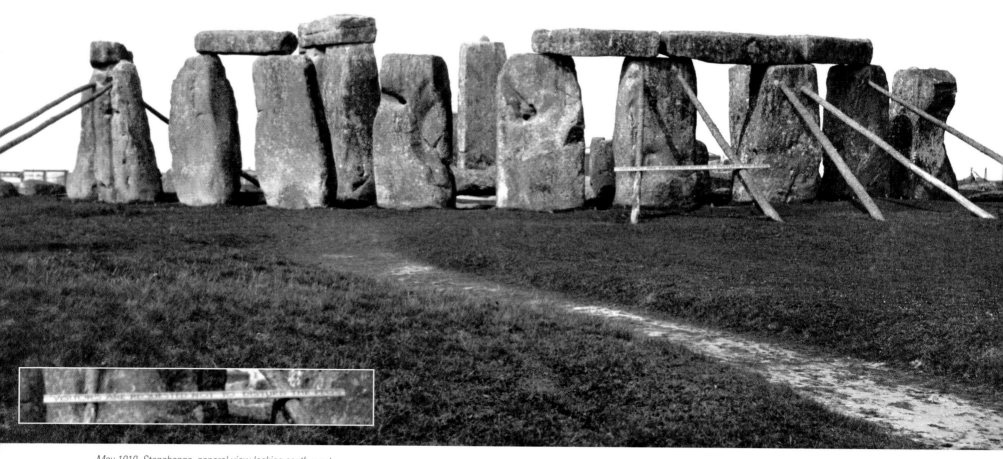

May 1919, Stonehenge, general view looking south-west
(NMR ALO 913/017/01)

Despite the concerns expressed during the war, the military had not caused major damage to Stonehenge either with their vehicles or with their explosions. However, some of the stones were still apparently held up only by the timbers that had been a fixture for years. This photograph, taken a year after the war had ended, shows them now to carry notices exhorting the public 'Not to disturb the pegs'. This presumably was the result of someone wanting to see what would happen if a prop was removed.

As Stonehenge was now the property of the Government, the Office of Works was able to carry out a full structural survey. This confirmed that there were real dangers and it was decided that these should be tackled immediately in a programme of cautious restoration. Any sense of going beyond necessary structural work and of 'smartening up' Stonehenge was to be avoided.

Restoration would inevitably require disturbance of the ground and Gowland's small excavation of 1901 had demonstrated the value of careful investigation. Gowland, who had done such a good job in 1901, would have been the obvious choice but he was now old and unwell so the job went to Colonel William Hawley, an experienced excavator, well known to the Office of Works.

Hawley is a distinctive figure, usually attired in tweed jacket and cap and with a moustache to rival Gowland's. Here, front row right, he poses confidently with his team against a background of engineering work. He might not, at this time, have realised what a long campaign of excavation his was to be.

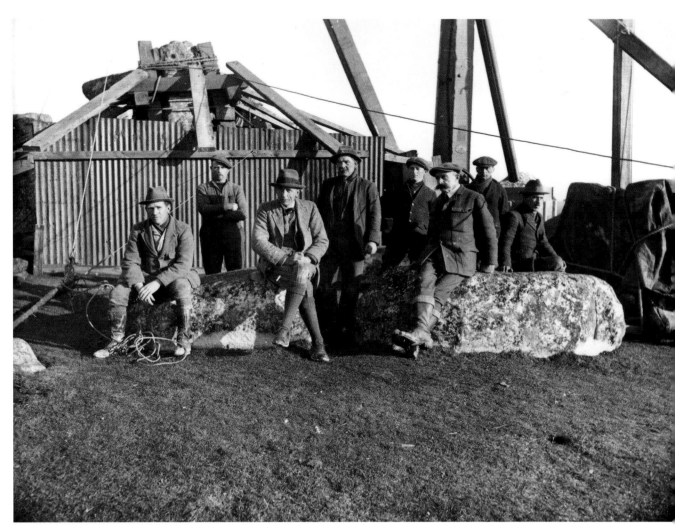

1919, A Trowbridge: Colonel Hawley and team (NMR BB81/861)

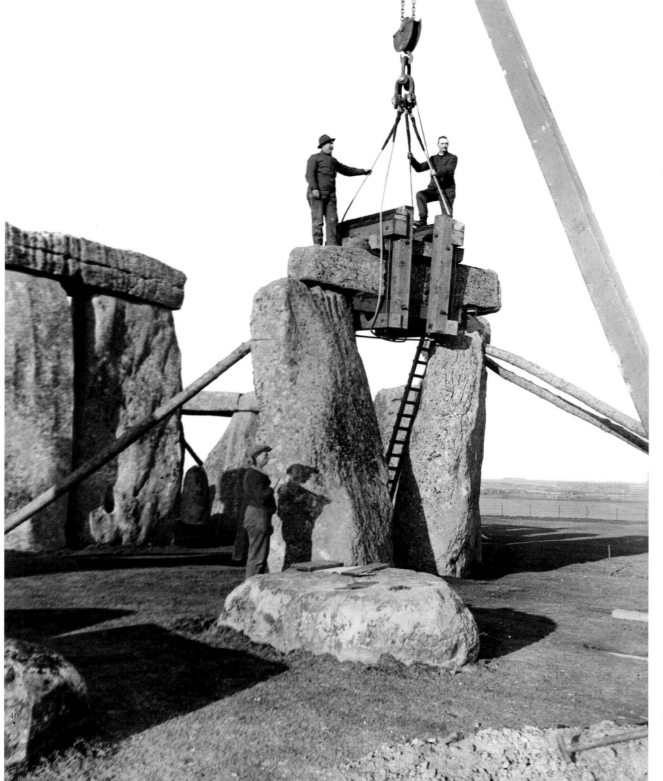

The restoration work began in November 1919 and tackled what was seen to be the most urgent problem. Stones 6 and 7, part of the outer sarsen circle on the east side, had both moved from the vertical, but in opposite directions, creating an unusual twisted structure on which their lintel was precariously balanced. In this case, as can be seen from the photograph, it appears that the wooden props were not simply cosmetic and may have actually prevented further collapse.

Here the first part of the operation is underway, the removal of the lintel. It has been carefully wrapped for its protection, encased in a sturdy timber frame and complete with intrepid, if not foolhardy attendants, appears to be ready for lifting.

November 1919, Adjustment of Stones 6 and 7.
Preparing lintel for removal (NMR ALO 913/039/01)

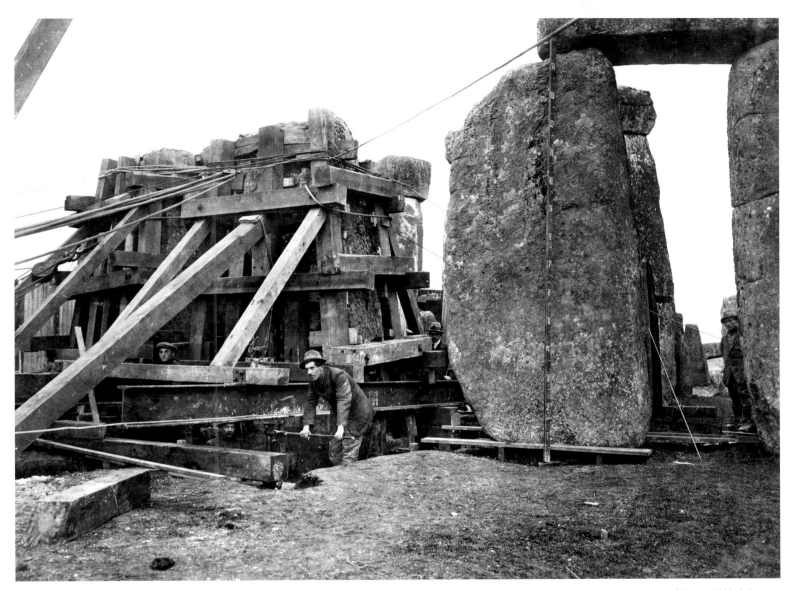

With the lintel removed the two uprights could themselves be encased in timber and then gradually eased back into an upright position by means of 'screw' jacks, massive versions of the jacks used to lift cars in order to change a wheel. Once the stones had regained the vertical they were firmly set in concrete and the first stage of the restoration was completed when, on the 17 March 1920, the lintel was replaced.

Part of Hawley's brief was to do what Gowland had done, simply excavate around the bases of the stones that were being straightened. This he did, and found very much the same sort of material that his predecessor had. But Hawley had been commissioned to do more than simply work alongside the engineers. While they secured the stones, he also started to empty Stonehenge's ditch.

February 1920, Adjustment of Stones 6 and 7, Stone 6 being brought into position by operating the screw jacks (NMR ALO 914/113/01)

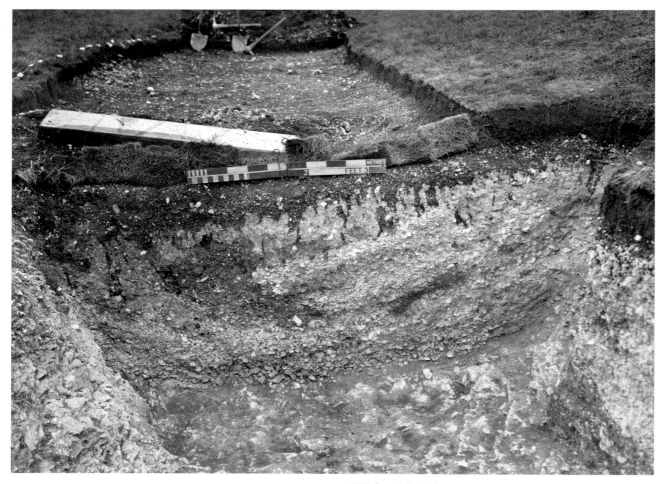

c *1920, One of Hawley's cuttings through the ditch at Stonehenge*
(NMR MPBW Photographs Collection)

Hawley's work at Stonehenge was carried out on behalf of the Society of Antiquaries, who felt that nothing short of complete clearance would help to understand Stonehenge. He started work on the ditch, emptying long lengths on the eastern side of the enclosure. This photograph shows it to be comparatively insignificant in size in comparison to the massive stone structures that lie within its circuit. Hawley found it to be irregular in profile, 'like the outline of a string of very badly made sausages' and contained little that interested him.

There was, however, one significant new discovery made in this first year of investigation. The 17th-century antiquarian John Aubrey had noticed shallow depressions in the ground on the inner edge of the bank. Hawley was persuaded to investigate this observation and found a circle of fifty-six regularly-spaced, circular, flat-bottomed pits. Twenty-one of them were investigated and all but four contained deposits of cremated human bone. These are the 'Aubrey Holes'.

The restoration work continued throughout 1920. Here, on the north-east side of the sarsen circle, workmen pose by a ten-ton lintel, suspended in its timber cradle ready for turning. This is one of three lintels that were removed prior to their supporting uprights being set into the now customary concrete. This stage of the restoration helped preserve the most complete and understandable section of the outer circle, the arc on the north-east side, closest to the entrance.

Although with the completion of this work Stonehenge had effectively been stabilised, there were originally plans to carry on into 1921 and replace the stones that had fallen in 1797 and 1900. In the end, no more money was made available and the restoration stopped in December 1920. Hawley's excavations did not.

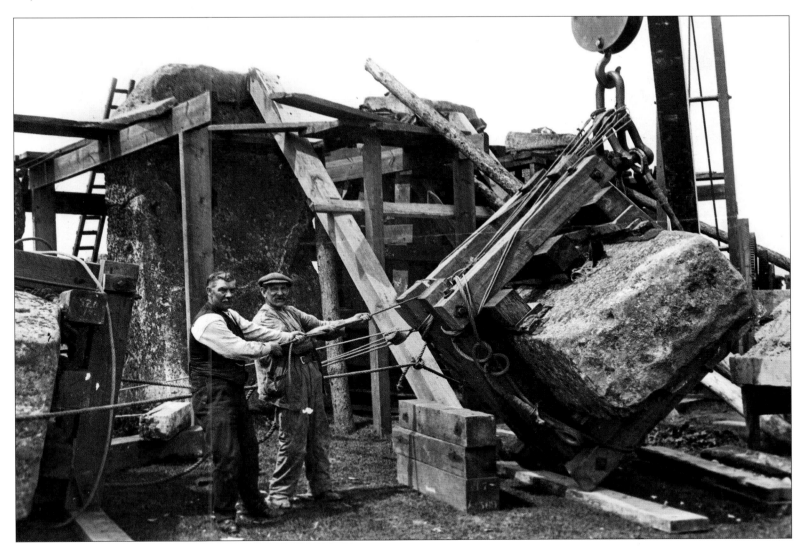

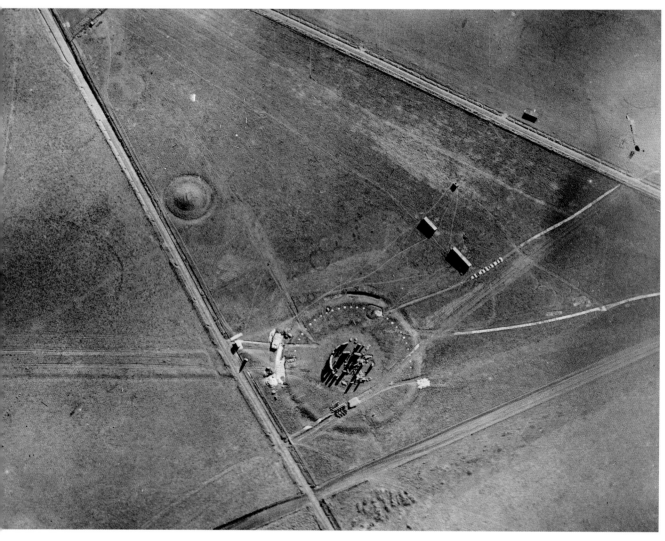

In this view, the old eroded tracks that caused so much concern have been grassed over, traffic now having been diverted onto a new straight track further to the west, away from the stones. Close to the bank the positions of excavated Aubrey Holes are marked by white chalk spots, later replaced in concrete. A dark arc of ditch shows a previous seasons investigation. There are huts and stores close by, and Hawley is still digging.

Colonel Hawley carried on working at Stonehenge until 1926. His digging seasons were long, from March to November and he often worked alone. His instructions were simple; excavate Stonehenge totally but cheaply. In the end he cleared half of the entire site, everything south east of the axis that runs north-east–south-west through the site and out through the entrance past the Heel Stone. He did make more new discoveries: two more rings of pits, the 'Y' and 'Z', holes lay just outside the stones.

Tragically, however, at the end of seven years work, carried out conscientiously and methodically, yet without any semblance of genuine enquiry, all Hawley could state was that: 'So very little is known about the place that what I say is mainly conjecture and it is to be hoped that future excavators will be able to throw more light upon it than I have done.'

For Stonehenge the Hawley years were a disaster.

early 1920s, Vertical aerial view of Stonehenge
(NMR MPBW Photographs Collection)

While Hawley dug on at Stonehenge Dr H H Thomas, a petrologist working for the Geological Survey of Great Britain, finally managed to locate the exact source of the mysterious bluestones. He was helped by his intimate knowledge of the geology of Wales and by advances in the scientific studies of rocks. Using samples taken from Wales and from Stonehenge itself, he created wafer-thin slices of rock in order to compare their precise mineral composition. In this way he traced their origin to outcrops close to the north Pembrokeshire coast, more than 130 miles from Stonehenge. Here in the Preseli Mountains the rocks require no quarrying or rough shaping, the forces of nature create natural megaliths.

2003, Julian Richards: The Preseli Mountains, Pembrokeshire, source of the Stonehenge bluestones

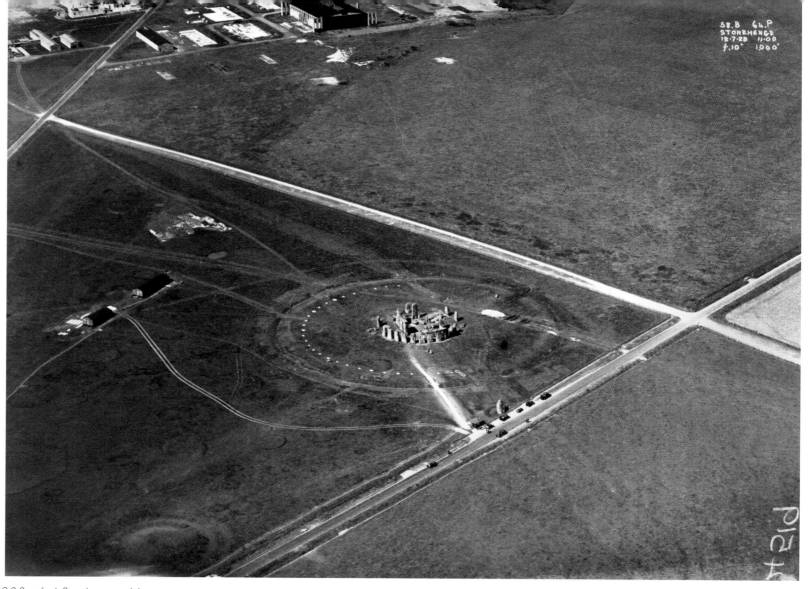

*12 July 1928, O G S Crawford: Stonehenge, aerial
view from the north-east (NMR Crawford SU 1242/89)*

With the departure of Colonel Hawley, theoretically to report more fully on his findings, the newly-stabilised Stonehenge settled down into decades that would see little change, except in the surrounding landscape. This view, by the celebrated aerial photographer O G S Crawford, shows Stonehenge from the north-east. Some of the clutter of Hawley's excavations is still in evidence, in particular the huts off to the left.

In the background are the buildings of the former aerodrome. The last planes had flown from there in 1920 after which the site was handed back to its former owners who used it initially as the Stonehenge pig farm.

Stonehenge itself seems remarkably quiet for the height of summer. The few visitors who have arrived by car have simply parked by the side of the road. There is a ticket office and little else.

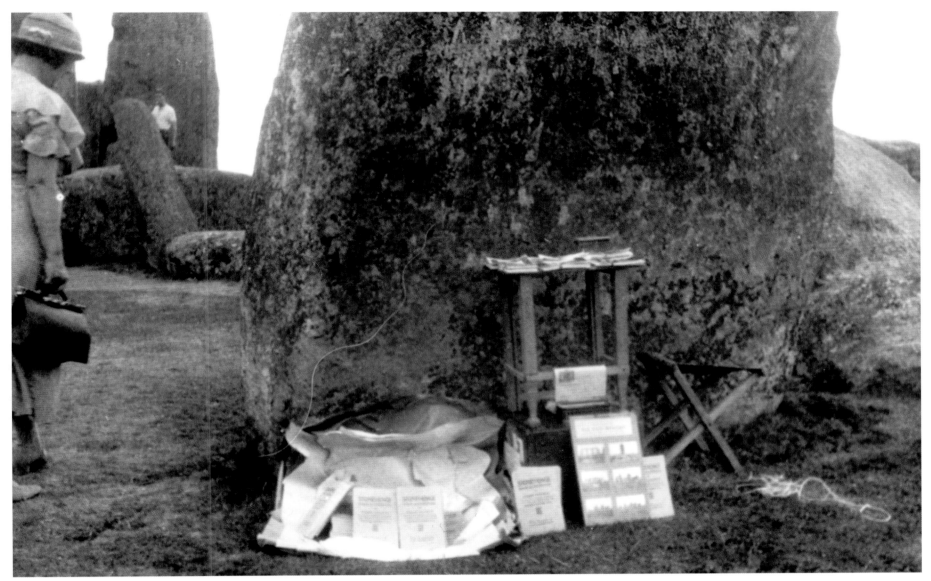

August 1935, 'My latest find at Stonehenge'
(NMR MPBW Photographs Collection)

1935 marked a change in the way that Stonehenge was managed. As more people bought cars, and coach travel became widespread, Stonehenge became more accessible. It featured in advertisements for Shell petrol and visitors could now number as many as 15,000 in a single summer month. Their cars blocked the road and the beleaguered custodian simply could not cope. The traffic problem was solved by creating a car park on the opposite side of the road, even though people still parked on the verge.

By this time Stonehenge boasted an official guidebook even if the marketing was somewhat low key.

This photograph, captioned 'my latest find at Stonehenge' was sent by a Mr Cunnington and shows the unattended sales point set up next to one of the sarsen trilithons.

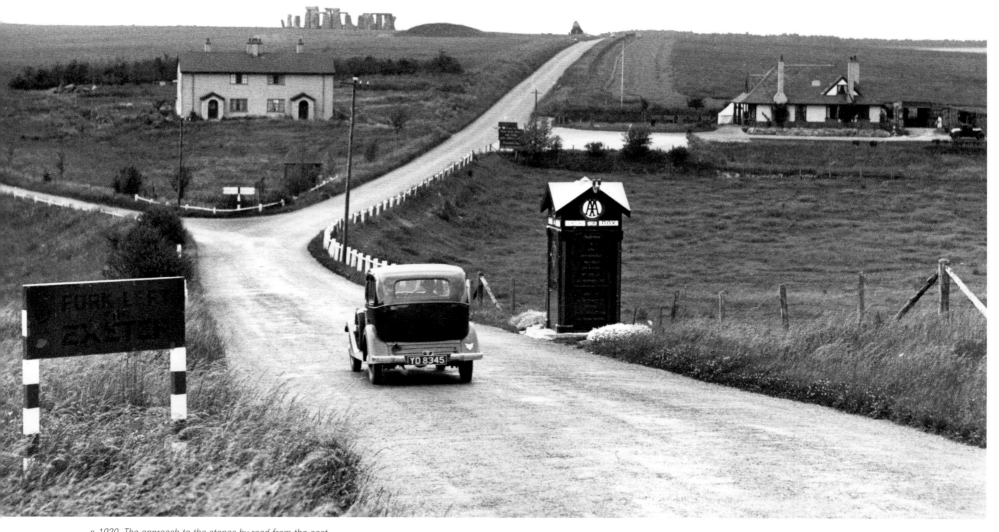

c *1930, The approach to the stones by road from the east*
(NMR MPBW Photographs Collection)

By 1930 attempts were being made to tidy up the surroundings of Stonehenge, surroundings that had become decidedly cluttered over the previous twenty years. After a national appeal 1,500 acres were purchased and, in order to safeguard them in perpetuity, were vested in the National Trust. To the west, the pig farm occupying the old airfield buildings was demolished; but more buildings had only recently been built to the east of Stonehenge.

This view is one that has been seen by countless millions of motorists and their passengers travelling along the A303 to the West Country. As the sign at the side of the road says, 'Fork left for Exeter'.

Stonehenge has not changed, but in 1930, in addition to the AA box, the view included two fairly new buildings. Dead ahead, in the fork of the roads, lie the custodians cottages, built in 1920, and on the opposite side of the A344 is the slightly more recent Stonehenge Café. This was not a popular addition to the setting of Stonehenge, being described at the time as 'a cheap, flashy little building like the worst type of bungaloid growth'. The cottages went first, the café followed soon afterwards.

An elderly gentleman, his stout boots, gaiters and stick suggesting that he had arrived at Stonehenge on foot, rests by the turnstiles at the side of the Amesbury to Devizes road.

For thirty-three years this was the way into Stonehenge for all legitimate visitors, but the low fence was incapable of deterring those bent on mischief. On the night of 16 June 1938, four young officers from the nearby School of Artillery at Larkhill, after a very rowdy guest night in the Mess, 'decided to paint Stonehenge'. Four stones were daubed green, two pieces of china were placed on top of the stones and 'Is this a friar?' was painted on the Heel Stone (a reference to this stone sometimes being known as the 'Friar's Heel'). It was also noted rather enigmatically that on returning to the car park they had 'added a letter to the word 'Exeter'. It does not require much imagination to guess which letter and where.

1940s, The Stonehenge turnstiles
(Wiltshire Record Office P 8427)

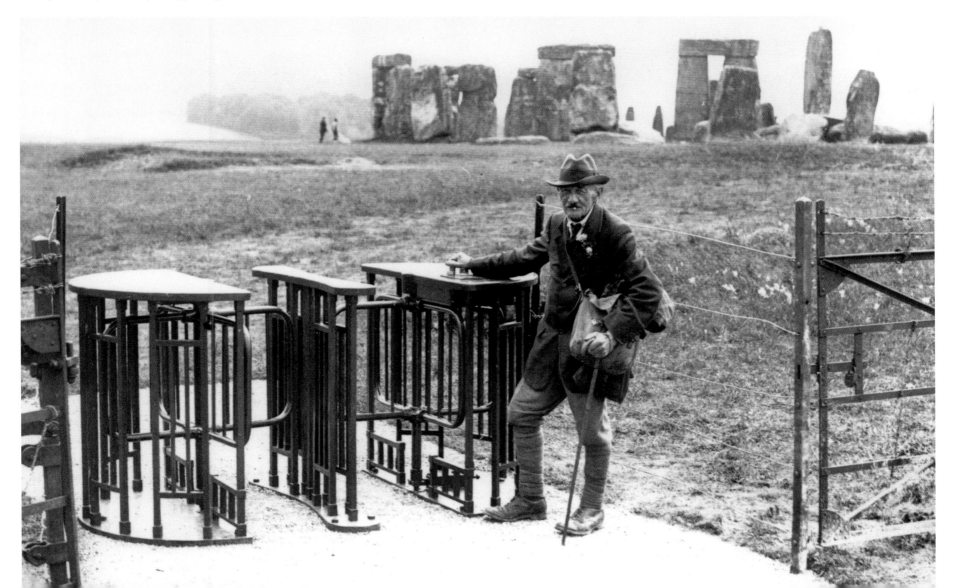

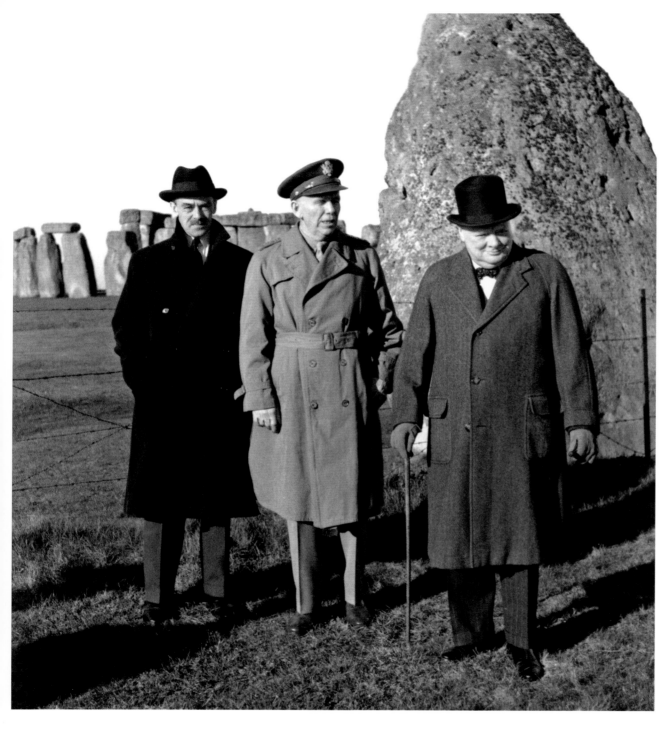

Winston Churchill, United States General Marshall and an unknown civilian stand by the Heel Stone.

The Second World War once again saw Stonehenge surrounded by intensive military activity. The skies buzzed with planes, from small grass air-fields and from the major RAF base to the east at Boscombe Down. To the north lay the vast Salisbury Plain Training Area (SPTA), more than 90,000 acres of chalk downland, which, incidentally, includes some spectacular archaeological sites. The SPTA includes large areas regarded by the military as 'good tank country' and Churchill's 1944 visit, which apparently did not allow enough time to go in for a proper look at Stonehenge, was to see new tanks being demonstrated over this terrain.

Fortunately there was to be no repetition of the incidents of the previous war. Stonehenge sat out the conflict in fenced-off isolation.

1944, Churchill at Stonehenge (Imperial War Museum H 18733)

It had been nearly a century since Sedgfield took that first photograph of the ancient stones, isolated on a windswept plain. It had been an eventful century, during which Stonehenge had changed hands, been commercialised, extensively excavated, seen celebrations and protests, and, not for the last time, daubed with paint. Many of these changes had been documented in photographs, but from the early 1950s onwards the sheer quantity of photographs increases hugely.

1950 saw the resumption of excavation, initially under the leadership of a trio of archaeologists: Atkinson, Piggott and Stone. The excavations continued until 1964 and, despite leaving problems of a similar kind to those left by Hawley in the 1920s, have also left a huge collection of photographs.

Atkinson was a prolific photographer and is credited with having taken many of the images from this period (even when he himself appears in the photograph). Many of the images in the National Monuments Record are contained within bound 'Atkinson' volumes that picture the work of excavation and restoration. For the most part, however, this collection does not consist of standard excavation photographs, neatly trowelled trenches devoid of human activity and enlivened only by a suitably-sized scale.

There are many other, sometimes less 'official', photographs that show the peripheral side of Stonehenge, the unusual and at times bizarre events that seem to take place in and around the stones. There are photographs of people simply enjoying Stonehenge and this is what makes this collection so refreshing. These photographs help to bring Stonehenge to life.

The story of Stonehenge from 1950 to 2004 becomes increasingly complicated. As well as excavation and restoration, the 1950s and 1960s would witness another collapse and a spate of graffiti attacks. The numbers of visitors would continue to rise and would inevitably change the way in which the monument was presented and explained. Stonehenge would at times become the focus for conflict, at other times a symbol of peaceful beliefs in the power of the earth and of ancient gods.

Chronicling these times and these changes through photographs is difficult. There are frustrations in being aware of events that took place and in not having the photographs to illustrate them. Equally there are frustrations in having fascinating images and being unable to discover the subject of the photograph. Consequently, what follows is inevitably only part of the story from 1950 to the present day. It is a richly illustrated miscellany, arranged under a series of headings that best represent the major themes of Stonehenge's history throughout these years.

EXCAVATION AND RESTORATION

In 1950 archaeologists once again turned their attention to Stonehenge. The Hawley years, seven seasons of excavation in which half of Stonehenge was stripped to the bedrock chalk, had left a legacy of unstudied finds and unwritten reports. The challenge of bringing this work to belated publication was taken up by Professor Atkinson of Cardiff University, Professor Piggott of Edinburgh and the Wiltshire archaeologist J F S Stone. From the outset however, they felt that some additional small-scale excavation might be needed in order to answer specific questions.

They began their work at Easter 1950 with the excavation of two of the unexamined Aubrey Holes, discovering more cremated human bone and confirming that they had never held upright timbers or stones. Small though these excavations were, it was a sample of charcoal from one of these Aubrey Holes that was to mark the beginning of a new age of scientific dating. Under the heading 'Stonehenge charcoal find, Radio-activity test' the *Daily Telegraph* of 12 May 1952 announced that Professor Willard Libby of the University of Chicago had arrived at a date of 1848 BC, plus or minus a margin of 275 years for the construction of Stonehenge. This was the first use of the newly-devised radiocarbon or C^{14} method to date an archaeological site. It may not seem over accurate, placing the earliest stage as somewhere between 2123 BC and 1573 BC, but this was the first time that Stonehenge had been given any real date, rather than simply being ascribed to some broad division of prehistoric time.

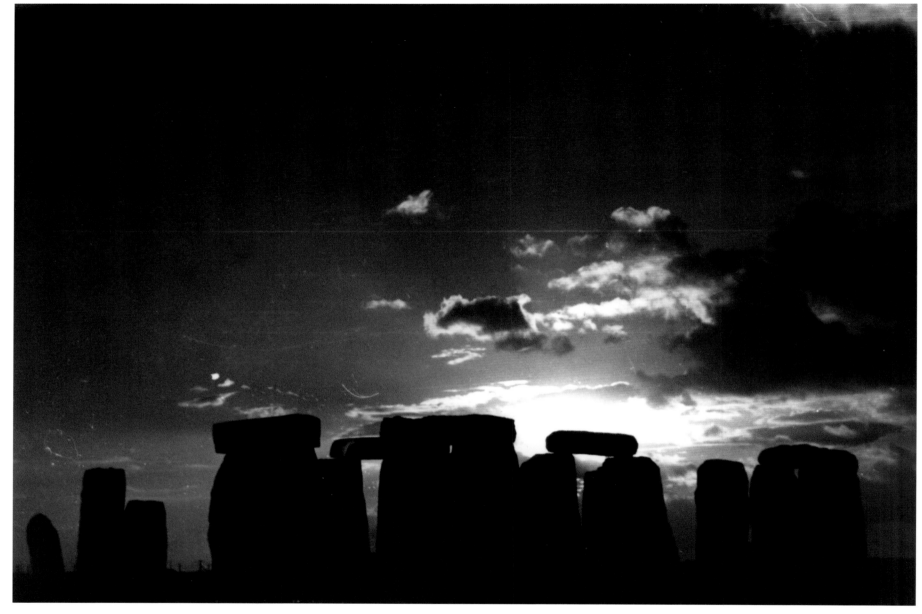

1953, Stonehenge at dusk, view from the east (NMR 1.19/5 (A box XIII))

The years during which Atkinson and Piggott were carrying out their investigations produced many wonderful photographs to accompany the archaeological discoveries. Stonehenge can seem at its most impressive with its stones silhouetted against a dying sun and a dramatic sky.

1953, Dagger carvings on Stone 53 (NMR 2.42/5 P52379)

Although there had been suggestions of prehistoric carvings on the stones from as early as 1893, it was only at 5 pm on 19 July 1953 that Professor Atkinson recognised outlines of axes and a dagger on the smooth surface of Stone 53. The axes were of a characteristic Bronze Age type, flat with a wide cutting edge and dating to *c* 1500 BC. Detailed study of the stones under the right lighting conditions led to the discovery of more than forty axe carvings. The dagger posed more of a problem, as the best comparisons initially appeared to be with examples from royal graves in Mycenean Greece. This similarity caused a flurry of speculation concerning the cultural origins of Stonehenge's architect but, in reality, the dagger is, like the axes, more likely to be of British origin.

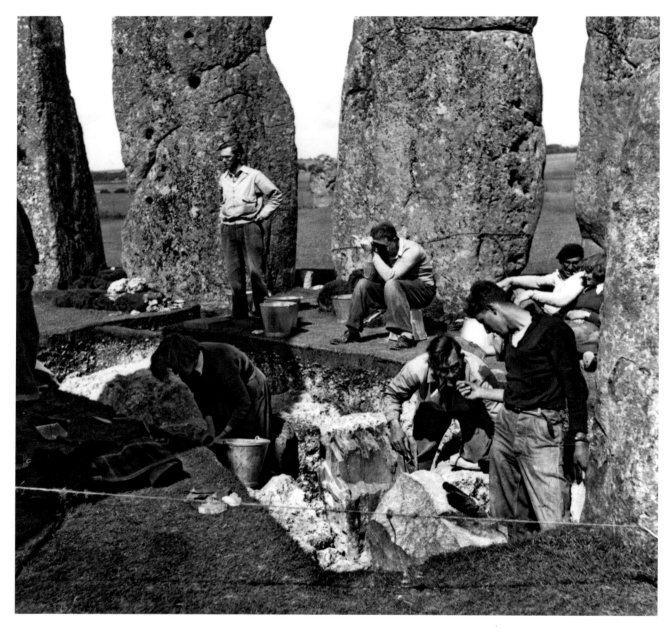

With the Heel Stone just visible in a gap between the uprights of the outer sarsen circle, excavations are taking place on part of the bluestone circle. In the trench the archaeologists have uncovered the buried stumps of stones that have long since disappeared above ground, demonstrating the variety of rocks that fall within the general description of 'bluestone'. In addition to the hard dolerites and rhyolites identified by Thomas in the 1920s there are also volcanic and calcareous ashes, rocks so soft that over the millennia they have mostly dissolved and only survive below ground.

1954, Excavation of Stones 32, 33 and others (NMR 888 P 50792)

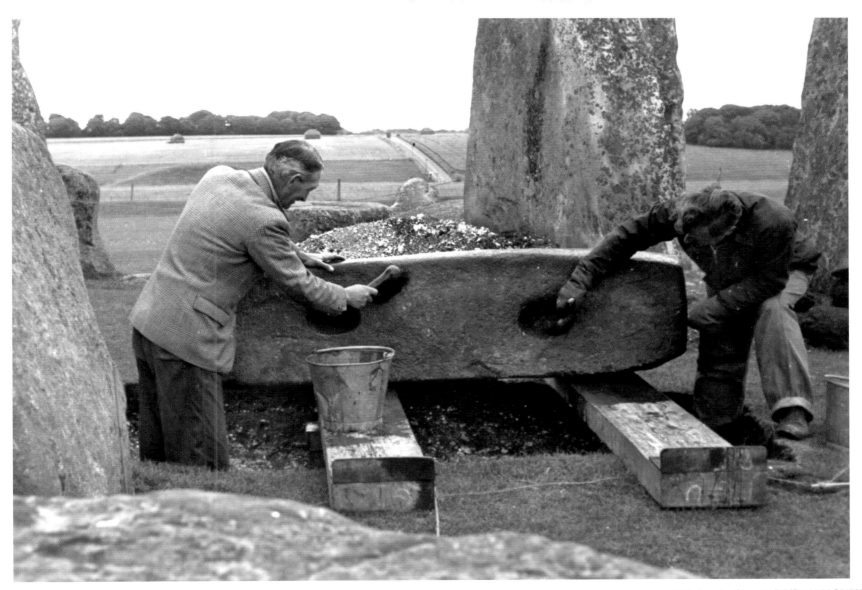

Stone 36 is an elegant bluestone lintel, here seen raised on baulks of timber and being given a good scrubbing after having been lifted in 1954. As he excavated, Atkinson was clearly developing his ideas about the sequence of construction at Stonehenge: when each part of the structure was built and in what order. But there were some stones, such as Stone 36, another lintel and at least two uprights with tenons – all of bluestone – that did not seem to fit

in with any neat sequence. These were evidence of miniature bluestone trilithons – but had they stood at Stonehenge, or somewhere else?

Work carried on in 1956, enlivened by the discovery, on 3 July, of an unexploded thirteen-pound shell. This was dismissed as 'quite harmless' by the military, who declined to carry out a precautionary sweep of the entire Stonehenge monument.

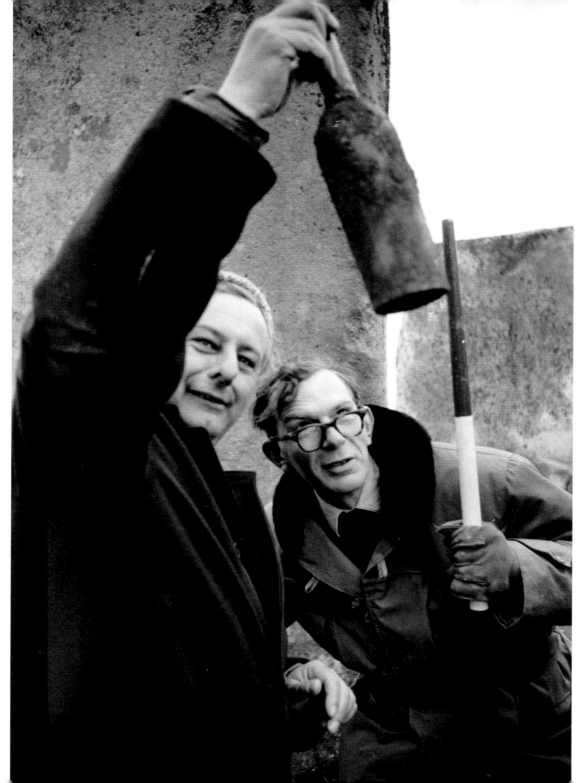

By 1958 the ambitions of the original excavation project had grown, as had the balance of power within the original triumvirate. When, in 1956, Atkinson wrote to the Ministry of Works to ask permission to carry out far more extensive excavations, it was to be under his and Piggott's direction, 'with the collaboration of Dr Stone'. By this time Atkinson had already published, in a book simply entitled *Stonehenge*, his interpretation of the building sequence, dividing it into three main phases. The new excavation work was intended to provide additional supporting evidence that would help to refine this sequence and that would eventually be published in a full excavation report. By 1956 there were also plans for further restoration work, with a requirement for even more archaeological investigation.

1958, Larry Burrows: Stuart Piggott (left) and Richard Atkinson examine an important find (NMR MPBW Photographs Collection)

This high view shows the aftermath of a series of collapses of parts of the sarsen structures. In the foreground is Stone 156, the lintel from the great trilithon, its mortice holes clearly visible. Beyond the standing bluestones are Stones 57 and 58, the recumbent uprights of the trilithon that fell in 1797, their lintel, 158, buried beneath a broken lintel of the outer sarsen circle. This, and one of its uprights, Stone 22, fell in 1900. Stone 21 still stands, although a little out of perpendicular.

In 1956 plans were drawn up to re-erect almost all of these fallen stones, with the exception of 156, even repairing the broken lintel. Work was scheduled to start in the spring of 1957 but the scale of the project meant that it was postponed until the following year.

The restorations of 1958 were extremely well documented in photographs. The selection that follows shows the remarkable scale and ambition of a project that would radically change the physical appearance of Stonehenge.

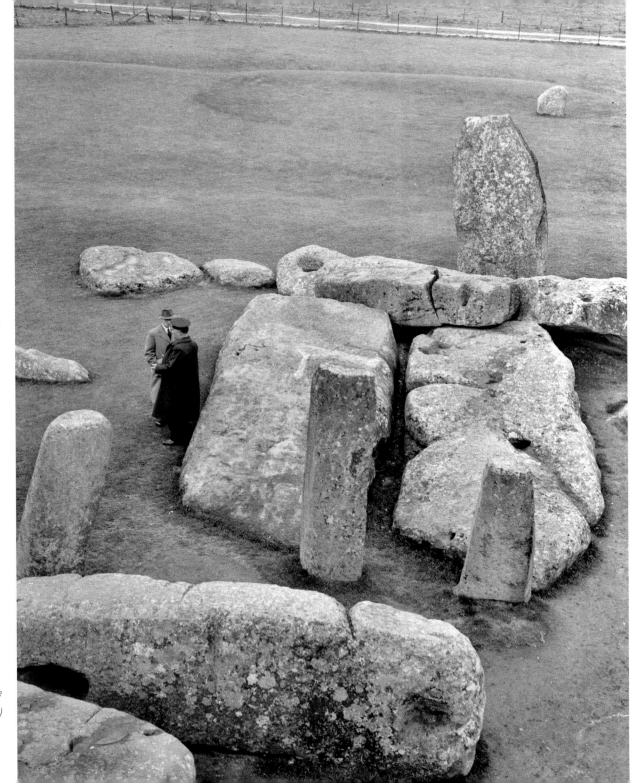

1955, An interior view from the east showing the results of the collapses of 1797 and 1900 (NMR ALO 914/044/01 A 4152/26 (gen vol 2))

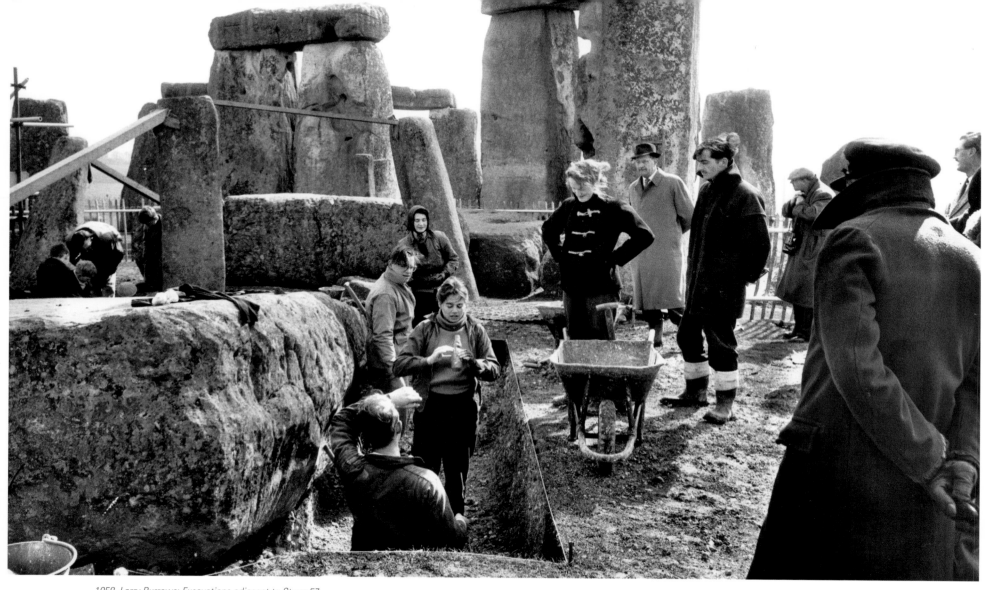

1958, Larry Burrows: Excavations adjacent to Stone 57, facing east (NMR MPBW Photographs Collection)

The excavations that Atkinson and Piggott started in late March 1958 were, like Hawley's early work, initially guided by engineering requirements. The restoration work planned for this season was more ambitious than any previously carried out: sizeable areas would need to be disturbed in order to re-set stones in concrete, and this would require extensive excavation.

Some stones could be removed comparatively easily but the two thirty-ton uprights of the fallen trilithon posed more of a problem. The first stage in the process of freeing these stones from the ground, in which they were firmly embedded, was the excavation of trenches alongside them. Here, adjacent to Stone 57, considerable interest is shown in the discovery of what appears to be a Victorian mineral water bottle.

The 'tide mark' around Stone 57 shows the depth to which it had become embedded in the soil and the boots protruding from the small hole underneath it show the dedication of one member of the excavation team. The directors, Atkinson and Piggott, remain at ground level, apparently waiting for the breakthrough that would enable a steel hawser to be passed underneath the stone. This was the only way in which these stones could be lifted.

In the foreground is a pile of bottle and jars, more of the more recent finds from the 'Stonehenge layer', a deposit that covered the whole site and contained everything from bluestone chips and Roman pottery to recent coins and shotgun cartridge caps. The finds from this trench appear to be from Victorian picnics, proof that littering ancient monuments is not entirely an invention of the 20th century.

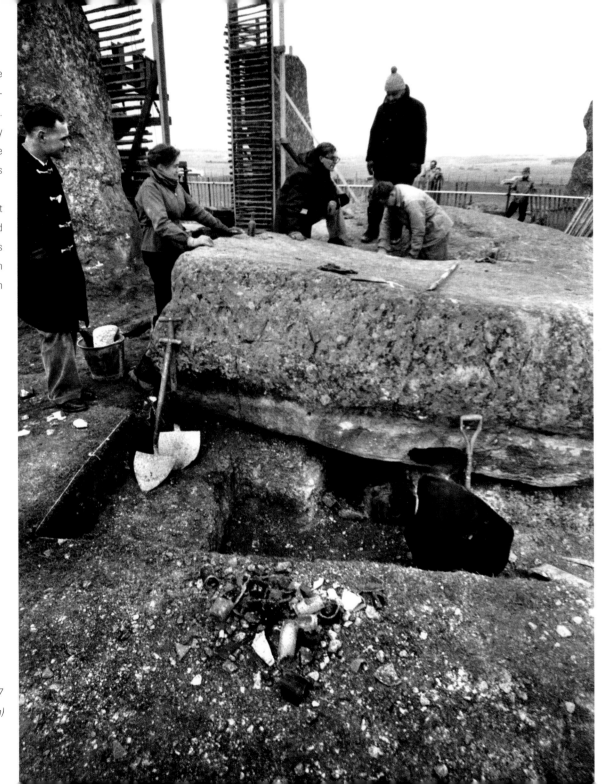

1958, Excavations around Stone 57
(NMR MPBW Photographs Collection)

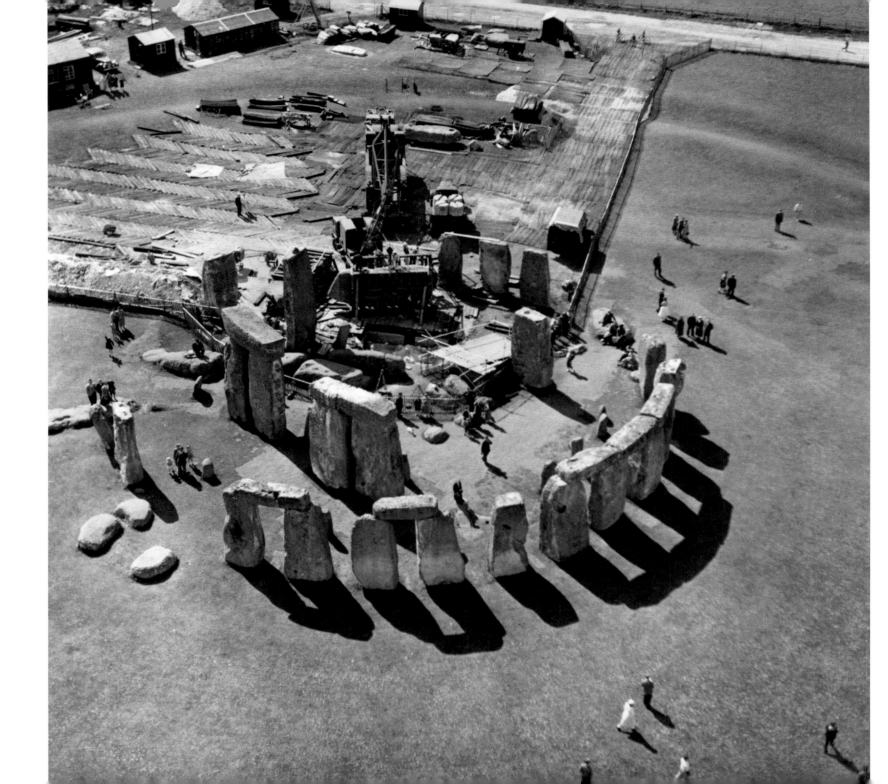

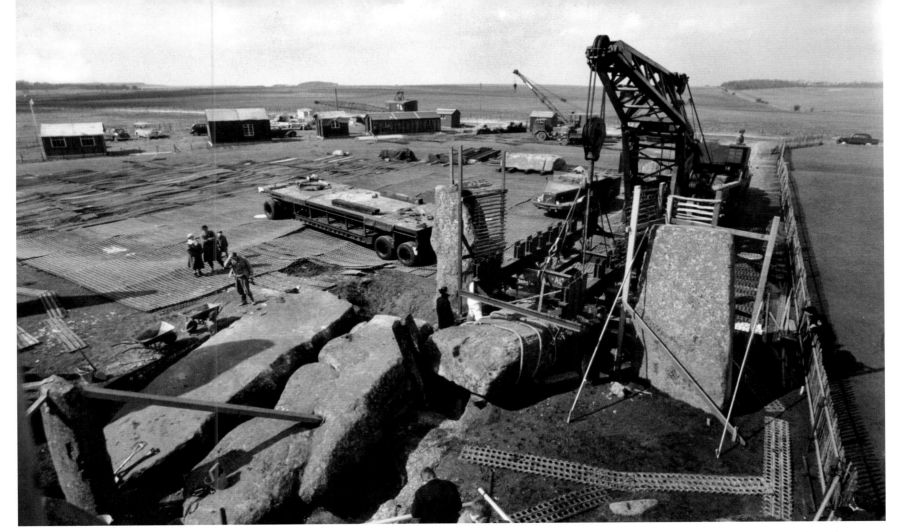

These photographs illustrate the huge scale of the engineering works that were carried out in 1958. In February and March an entire quadrant of Stonehenge was taken over by the Ministry of Works. The site was prepared by laying down protective 'Airstrip' matting and an additional layer of railway sleepers in the area designated as the 'stone park' where removed stones would be stored prior to re-erection. Services were laid on; offices and stores, a mess room and ablutions, and even a dormitory were built. A publicity platform was built on the assumption that there would be considerable interest from the press. Giant cranes appeared but, meanwhile, on the remaining three quarters of the monument, it was business as usual.

With stones now lying in their designated parking area and excavations well under way around the two fallen uprights, this photograph shows preparations under way for the lifting of Stone 22. The stones that lie on either side of it have been given a modicum of protection, unfortunately not sufficient to fully protect number 23, the stone to its right. This was given a hefty clout while Stone 22 was being lifted, and although it was not considered at the time to have been destabilised, this may be the reason why it unexpectedly fell over in March 1963.

In this raised view (opposite, left) Stone 21 is being made upright. Next to it Stone 22 has been replaced but is now encased in timbers and surmounted by a workman.

In the foreground Atkinson and Piggott are drawing plans in the area formerly occupied by the sarsens of the fallen trilithon. These stones have long been removed and the entire area, previously undisturbed, has been excavated down to the level of the bedrock. The pitted and cratered appearance of the chalk is testimony to the complexity of Stonehenge's building history. Each depression could potentially mark the position of a stone or a timber, some belonging to arrangements that can still be recognised, albeit in a fragmentary state, others perhaps to long vanished structures.

If Richard Atkinson was the photographer, then Stuart Piggott was renowned for his draughtsmanship. Here Atkinson (opposite, right), with trademark cigarette holder, takes measurements while Piggott, on the evidence of the photographs rarely without his woolly hat, draws the plan.

This photograph illustrates the relative shallowness of the hole that originally contained Stone 58. The impression of its base can be seen in the bowl-like object at Atkinson's feet and the dry-stone-wall-like structure is packing for the stone. This was a common discovery, the only way to raise a large stone to the vertical was by sliding it into a hole with a sloping side and then, by a combination of hauling and levering, raise it to the vertical. This would leave the base of the stone unsupported on at least one side so, in order to provide stability the hole was backfilled with chalk and fragments of left over sarsen and bluestone. Rammed in, these would fix the stone firmly in its socket.

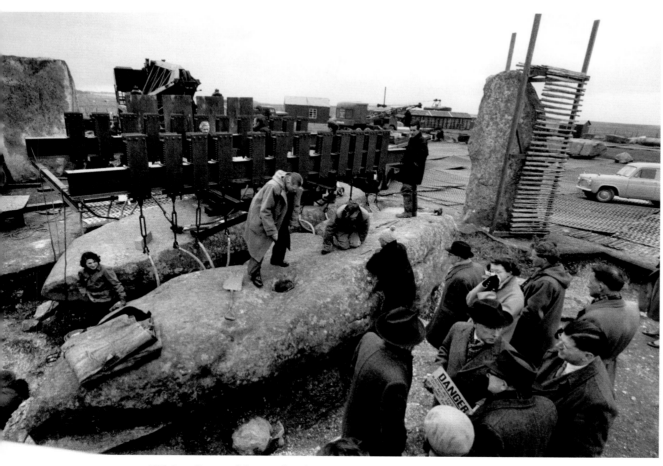

1958, Larry Burrows: Science at Stonehenge
(NMR MPBW Photographs Collection)

With Stone 57 freed up and slung underneath its steel cradle ready to lift, Atkinson and Piggott examine the surface of Stone 58 in minute detail. There were concerns about the possibility of undetected fractures within the fallen stones, fractures that could spell disaster when the stone was lifted, but which could perhaps be detected by the use of X-rays. One of the party of official-looking bystanders in the foreground is holding a sign saying 'Danger Radio Active' and advising the public not to pass beyond this point, wherever this point was. There are also enigmatic photographs that appear to show stones being scanned with devices that may be portable X-ray equipment.

1958, (opposite, left) Larry Burrows: Excavation taking place after removal of the fallen trilithon (NMR MPBW Photographs Collection)

1958, (opposite, right) Larry Burrows: Piggott and Atkinson planning the hole for Stone 58 (NMR MPBW Photographs Collection)

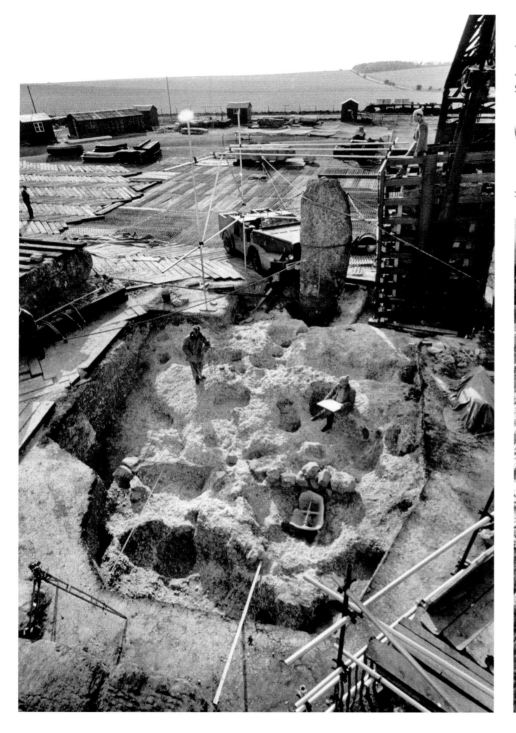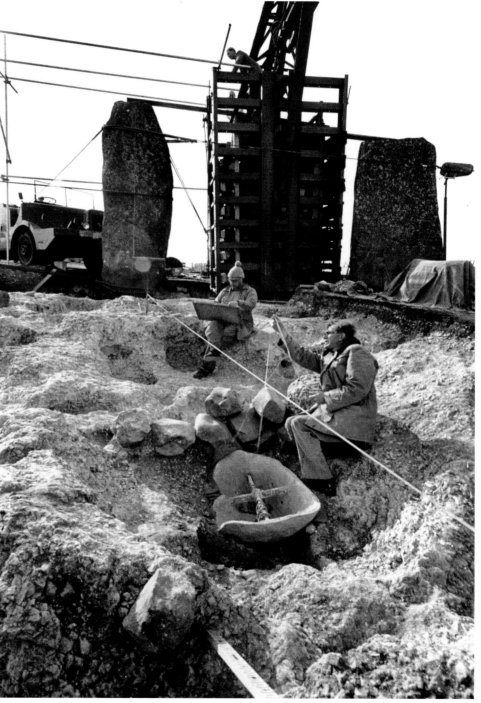

1958, Larry Burrows: A VIP visit
(NMR MPBW Photographs Collection)

1958 was clearly a very busy excavation season but there was still time for public relations. The military were still Stonehenge's closest neighbours and were accorded VIP status whenever they paid a visit. There might also have been an ulterior motive, as the local military had certain equipment that was of use in moving large stones. Here Richard Atkinson is no doubt explaining the importance of Stonehenge, while Stuart Piggott appears to be marching in step with the rearguard. The man in the white boiler suit is T A Bailey, the senior architect from the Ancient Monuments Branch of the Ministry of Works.

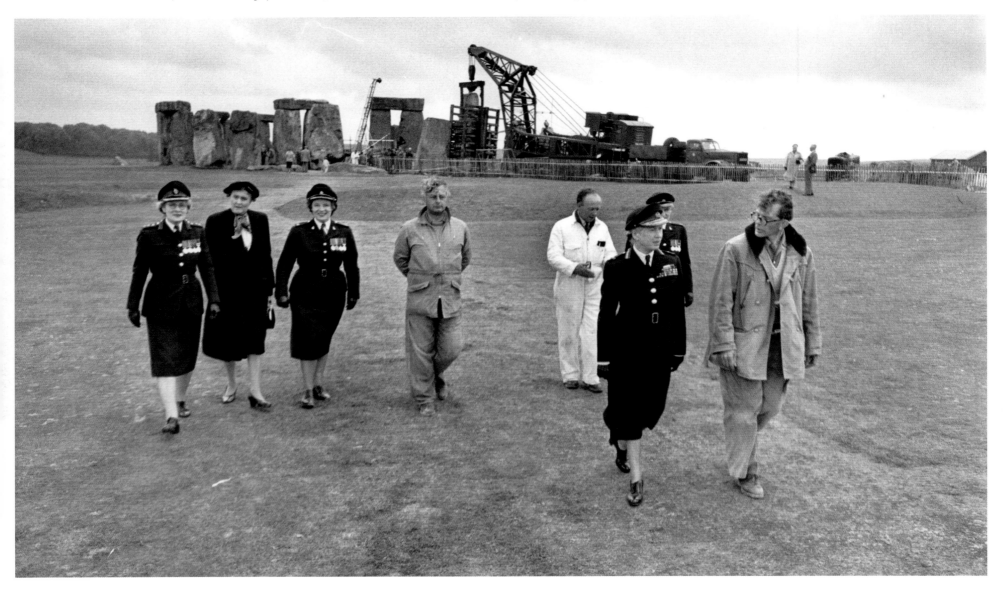

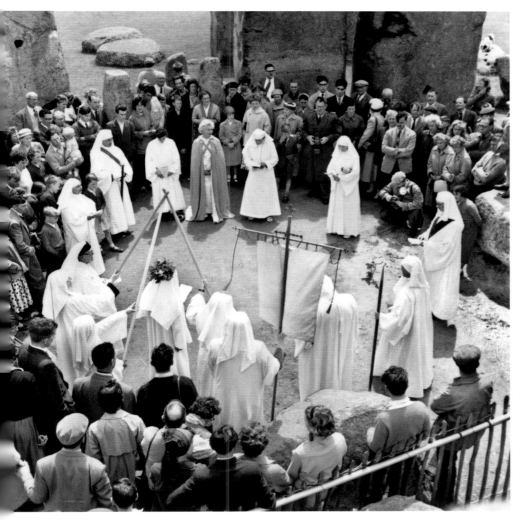

1958, Druids at the Summer Solstice (NMR 36/261 P 50247)

1958, An educational visit (NMR 38/282 P 50265)

There might have been slightly restricted standing room in the centre of the stones but even amidst all the reconstruction, some aspects of Stonehenge's annual routine went on as usual. Here, with the fence marking the edge of the construction site in the foreground, a group of Druids observed by a modest crowd of spectators, carry out a solemn ceremony in the summer of 1958. Construction work was apparently suspended for the duration of such ceremonies.

In the days before strict Health and Safety regulations either existed or were enforced there were few restrictions to access providing that you knew the right person. Here, within the engineering compound one of the excavation team appears to be giving an impromptu prehistory lesson to a group of schoolboys, who were possibly more interested in the machinery than in the stones.

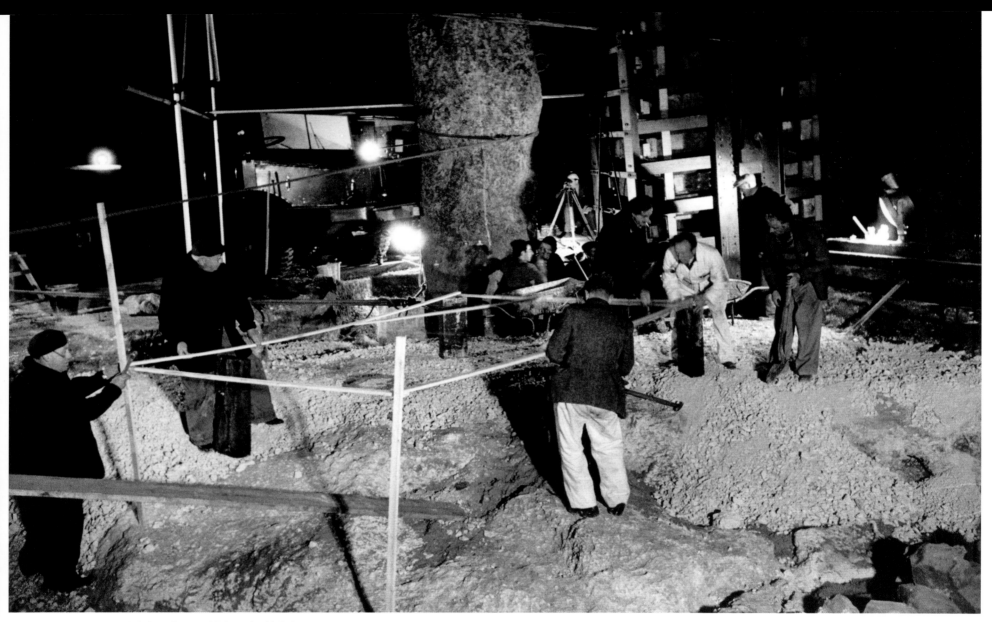

1958, Larry Burrows: Night works. Mr Bailey, the boiler-suited senior architect, supervises reinstatement work prior to the re-erection of the uprights of the fallen trilithon (NMR MPBW Photographs Collection)

The projected schedule for the work to be carried out in 1958 seems impossibly tight. It started on 24 February with four weeks preparatory work followed by five weeks for the removal of stones, during which time the archaeologists would also start work. Six weeks were allowed for the re-instatement of stones, with this stage to be completed by 9 June. This left a further two weeks for completion, the specification stating that the contractors must 'leave site perfect' by 21 June, just in time for the Summer Solstice. This is perhaps the reason why a dormitory was among the buildings that were constructed at the very beginning of the season: accommodation for the night shift.

The restoration of Stonehenge was very labour intensive. Apart from the archaeological team, local contractors supplied foremen, labourers, drivers, crane operators and carpenters. In 1956 James and Crockerell Ltd from the nearby village of Durrington ('Decorating, plumbing etc') supplied both plant and labour at a total cost of £253.13.4½, their workmen earning just short of four shillings (20p) an hour.

On the evidence of this photograph it was obviously more entertaining to work at Stonehenge than on the average building site.

The final stage in the process of raising the trilithon was the replacement of the lintel on the newly-erected uprights. This delicate operation was carried out using a crane borrowed from the nearby RAF station at Boscombe Down near Amesbury. This was the 'Brabazon Crane', so called because it was built specifically to lift the prototype of the plane of this name in the event of a crash. This crane, or rather the inexperience of its operator, nearly flattened Atkinson beneath a descending stone. Only the insertion of a piece of metal into the mechanism by the panicking driver prevented the tragedy.

1958, Replacing the lintel on the restored trilithon (NMR P 50216)

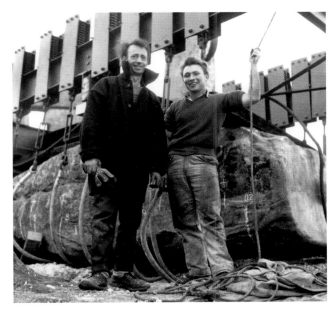

1958, Larry Burrows: Workmen (NMR 1069 P 51064)

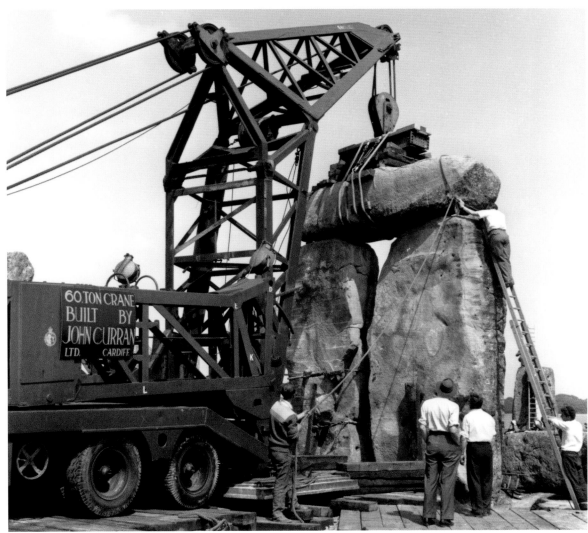

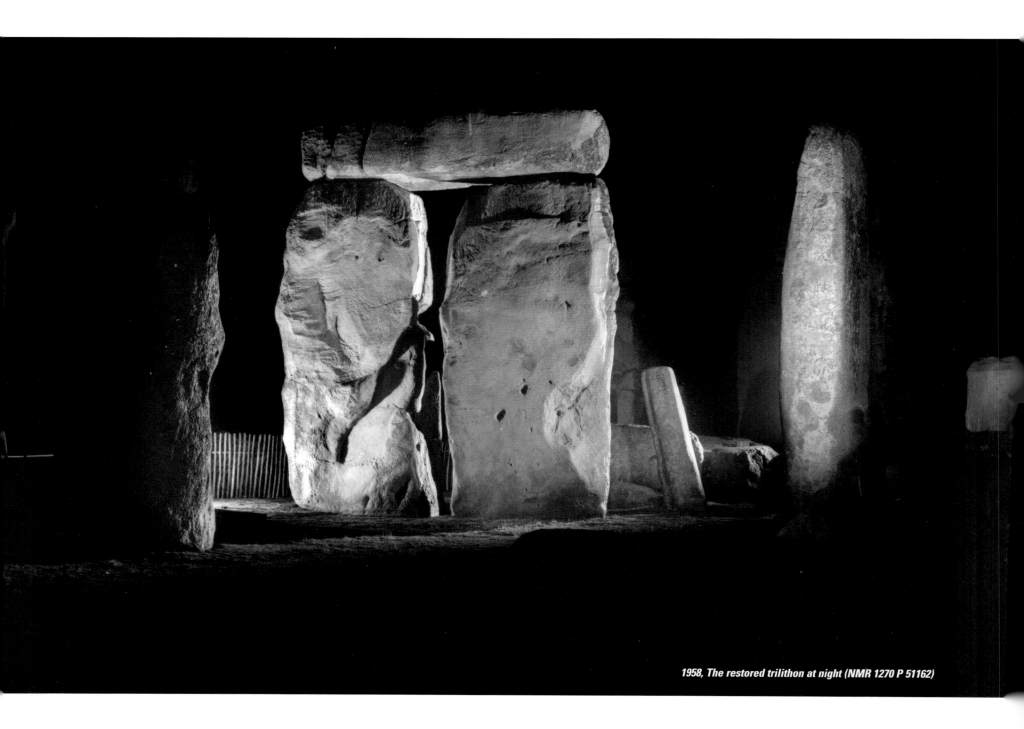

1958, The restored trilithon at night (NMR 1270 P 51162)

Whether or not Stonehenge was left 'perfect' at the end of the 1958 restoration was never recorded, but the results were spectacular. With the raising of the trilithon and the stones of the outer circle, the western side of the stones took on an entirely new appearance and the sarsen horseshoe, so fragmentary for more than 150 years, became far easier to visualise.

With its feet set firmly in concrete and surrounded with newly-laid turf, at any time of the day or night the restored trilithon is a powerful structure.

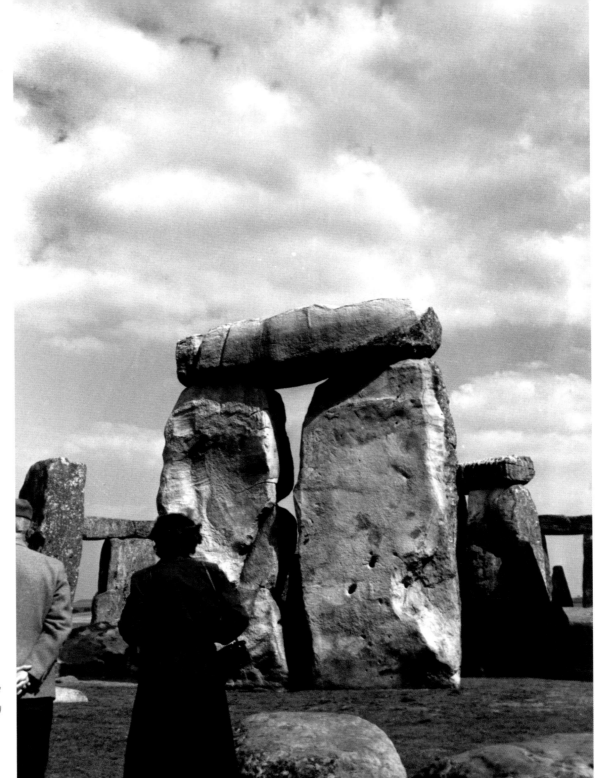

1959, The restored trilithon, Stones 57, 58 and 158
from the west (NMR 2.33/16 P 52332)

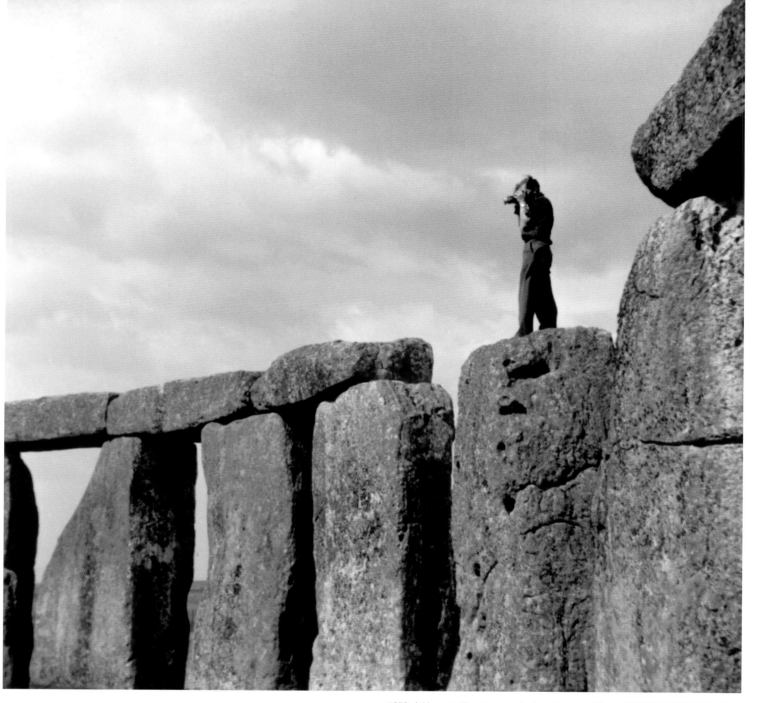

1958, Atkinson taking photographs from the top of Stone 3 (NMR 60/506 P 50464)

Richard Atkinson was a prolific photo grapher, with an eye for dramatic angles and the effects of light and shade on the stones of Stonehenge. But, as an archaeologist, how well did he serve Stonehenge?

When the original team of Atkinson, Piggott and Stone carried out their first excavation in 1950 they were only too aware of the Hawley legacy, the unstudied finds and the unwritten reports. Their intention was to deal with this deficiency in the archaeological record of Stonehenge, writing the long-overdue reports based on the information left by Hawley and only carrying out small excavations that would help to clarify specific problems. Small excavations, however, turned into large excavations, partly in response to the new programme of restoration with its requirements for investigation prior to any disturbance of the ground, and partly as pure research.

As the digging continued it was Atkinson who took the leading role and who published a summary of the new findings in 1956. Consequently, when the work was finally finished in 1964, the year that this photograph was taken, it was Atkinson who took responsibility for the preparation of the final report. Unfortunately, it was not until 1995, a year after Atkinson's death, that a volume appeared, produced by Wessex Archaeology and entitled *Stonehenge in its landscape: twentieth-century excavations.* In this volume are the long-awaited results of the excavations carried out both by Hawley and by Atkinson, and it is a great tribute to the team who produced this volume that they were able to make much out of the unsatisfactory site records. The Hawley years, 1919–1926, were referred to by Christopher Chippindale in *Stonehenge Complete* as 'a disaster'. But in Wessex Archaeology's 1995 report it is noted that there were also considerable problems with the records of Atkinson's excavations. They note that 'no written site records have been found from the 1950–64 excavations and it seems that none were produced'; and 'some of the original site drawings are no longer available for consultation'; and 'almost no documentation accompanied the photographs'.

Stonehenge, Britain's most important prehistoric monument and a site of extraordinary complexity, should have been better excavated and better recorded. Of those who led excavations at Stonehenge during the 20th century, only Gowland, the non-archaeologist, emerges with real credit.

1958, Tooling on Stone 54 (NMR 12/32 P 50027)

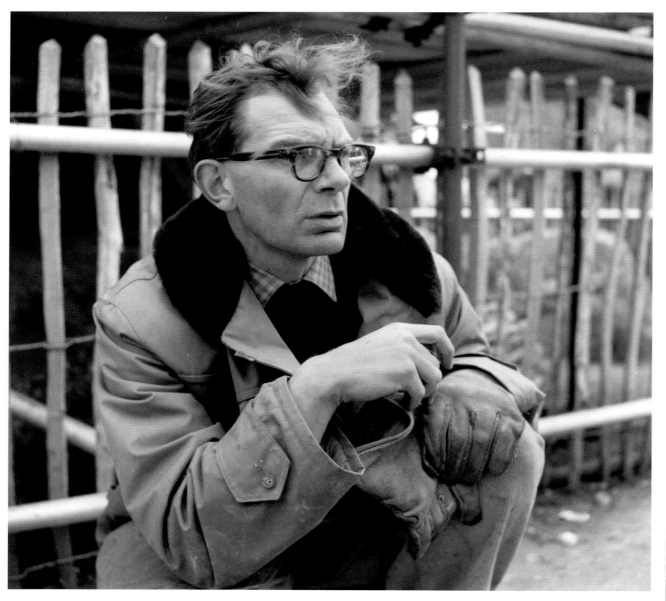

1964, Professor R J Atkinson in pensive mood (NMR MPBW Photographs Collection)

The photograph below, like many from this era, lacks any supporting information to say what is going on and when. In this case the lorry, or more specifically its registration, provides the clue. BBL492B was registered in 1964, the year of the final restoration.

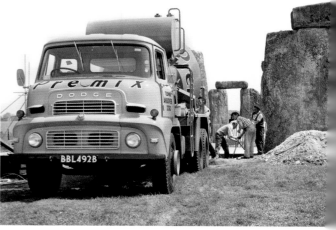

1964, The final concreting (NMR MPBW Photographs Collection)

Stone 23 of the outer sarsen circle fell during the severe winter of 1963 and was re-erected during May and June 1964. At the same time the opportunity was taken to straighten sarsens 27 and 28 of the outer circle and uprights 53 and 54 of one of the surviving trilithons. In this photograph Professor Atkinson, plumb bob in hand, and observed closely by Mr Bailey of the Ministry of Works, ensures that Stone 53 will fit snugly into its new concrete socket. Stuart Piggott observes from the crowd.

These were the final stones to be re-set in a long process of what, for Stonehenge, had effectively been cosmetic dentistry. Over sixty-three years stones had been straightened, firmed up, replaced in their sockets, had new sockets built for them, been scrubbed, repaired and had their cavities filled. Stonehenge had neither been left to crumble nor suffered the indignity of a complete rebuild. What was finished in June 1964 is effectively the Stonehenge that we see today.

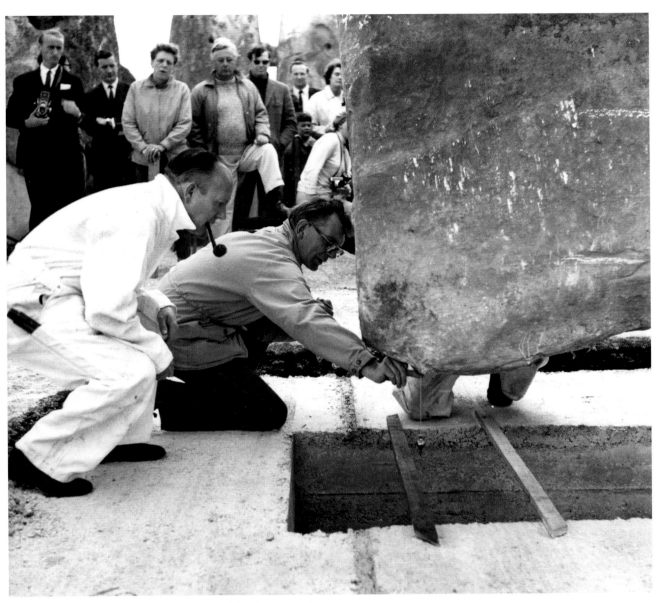

1964, Atkinson checking the final position of Stone 53 (NMR A6498/28 ALO 918/034/01)

1954, The bluestone replica on the River Avon
(NMR 1.70/26 P 51701)

EXPERIMENTATION

Since 1923, when the geologist Dr H H Thomas confirmed the source of the bluestones to be the Preseli Mountains in Wales, debate has raged on the subject of how they got to Stonehenge.

There are two conflicting schools of thought. One favours natural transportation, suggesting that the stones were carried eastwards by glacial ice and dumped somewhere on Salisbury Plain, from where they were collected and incorporated into the structure of Stonehenge. This idea seems less plausible when the almost total absence of any other stones

from a Welsh source in the vicinity of Stonehenge is taken into account.

The alternative is to suggest human transportation. This would involve moving about eighty stones, each weighing several tons, over a distance of more than 160 miles (as the crow flies), at a time long before the invention of the wheel and when there is little evidence for the use of animals to provide motive power. Yet despite these deficiencies human transportation appears to be the most likely explanation. After all, the sarsens, weighing up to forty tons, were moved more than twenty miles from their source on the Marlborough Downs. By comparison the bluestones were a more manageable size.

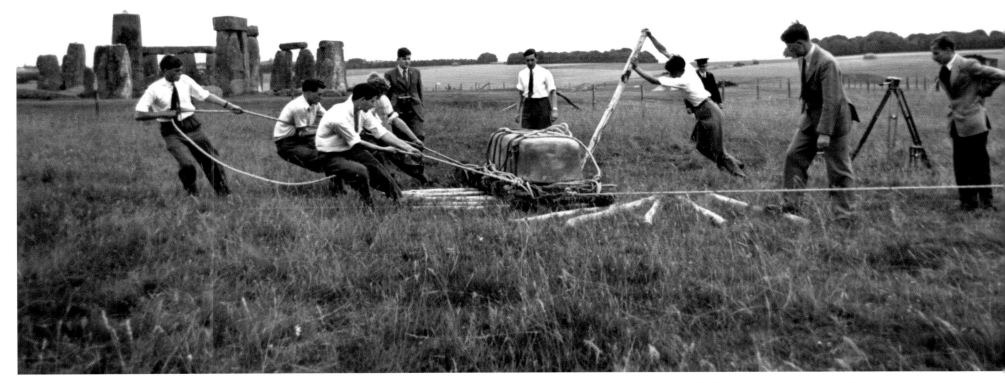

1954, Moving a bluestone replica on a sledge
(NMR 1.69/17 P 51692)

Richard Atkinson gave considerable thought to the route by which the bluestones could have arrived at Stonehenge. His preferred option was one that took the shortest overland route, from Preseli to the coast at Milford Haven (the possible source of the Altar Stone) and from there onwards, was by water. By hugging the Welsh coastline and then following a series of rivers, it was possible to arrive at a point on the Hampshire Avon less than a mile from Stonehenge.

An experiment was needed to demonstrate that a bluestone, or at least a replica, could be transported by water and on land. In 1954 punts were lashed together, rollers and ropes were procured and with the assistance of a group of eager schoolboys, the stone was taken on the last part of its suggested journey and delivered to Stonehenge.

Professor Atkinson had demonstrated that a one and a half-ton replica bluestone could be dragged across level grass on a simple sledge by a team of thirty-two haulers. The sarsens, however, weigh up to forty tons each, so how were they moved and, once at Stonehenge, how were they set up? There were many theories, and over the years estimates for the numbers of people required simply to move a stone varied from 90 to 1500.

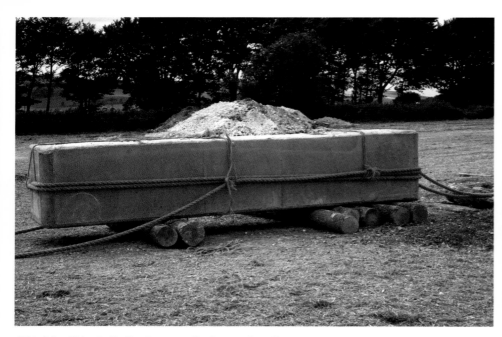

1994, Julian Richards: Hauling the ten-ton lintel on wooden rollers

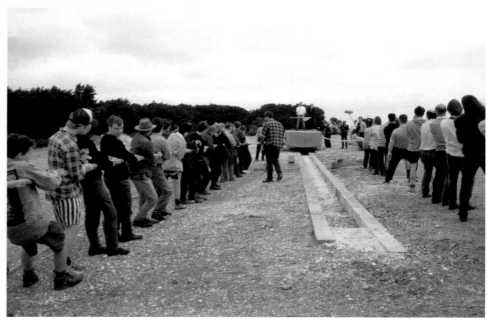

1994, Julian Richards: Hauling the forty-ton upright along wooden rails

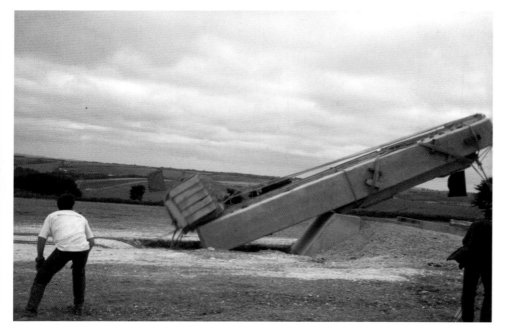

1994, Julian Richards: Tipping an upright into position

The only way to find out would be by means of another experiment, but on a far greater scale. Fortunately, in 1994 the BBC decided to carry out just such an experiment, as part of a series called *Secrets of Lost Empires*.

The components of the great trilithon, two forty-ton uprights and a ten-ton lintel, complete with mortice holes and tenons, were recreated in reinforced concrete. An engineer, Mark Whitby, was given the task of moving and assembling the stones using only tools and materials available to the original builders. Archaeological guidance was provided by the author; and Roger Hopkins, an American stone mason, came up with some alternative ideas.

It turned out to be possible to move the ten-ton lintel on rollers, most commonly assumed to have been the original method. However, this did not work with the forty-ton uprights. Eventually Mark came up with the idea of a solid wooden sledge running on wooden rails set slightly into the ground. A central protruding 'keel' on the base of the sledge kept it on the rails. With a little lubrication it was found that the stone could be hauled up a 1:20 slope by a team of 130 volunteers.

Mark devised an ingenious way of raising the stones to the vertical.

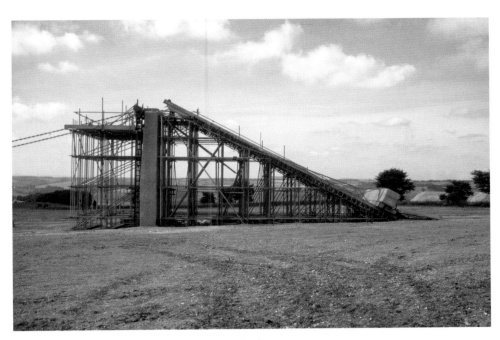

1994, Julian Richards: The 'earth' ramp for raising the lintel

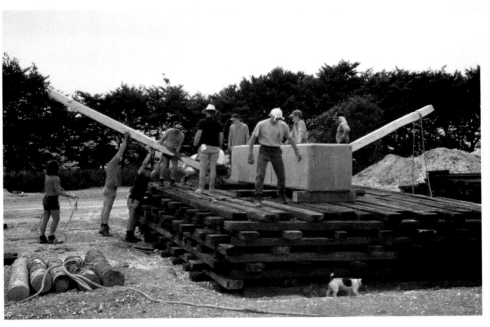

1994, Julian Richards: The wooden crib and lever method for raising the lintel

The upright was poised on a ramp over its stone hole, into which it was tipped by means of a bundle of smaller 'stones' being dragged along its length. Once in position it could be hauled upright by means of ropes and an 'A' frame.

This left the placing of the lintel on the uprights. Mark Whitby's solution was the creation of an 'earth' ramp (actually made of scaffolding in the experiment) up which the lintel was dragged. This worked, but seemed over elaborate and would have involved the moving of hundreds of tons of earth for each ramp. A less elaborate, but equally efficient and potentially safer method was suggested by Roger Hopkins: the by now traditional timber 'crib'. On the stable platform of interlaced timbers, in this case railway sleepers, the lintel was gradually raised by the use of levers. Given levers of a suitable length and strength, this is surprisingly easy and the resultant wooden structure is easy to dismantle and re-use.

The end product was a full-sized concrete replica of the Great Trilithon, erected (mostly) by human hand. Seen here with Mark (left) and Roger, it was sadly dismantled after rapidly becoming a place of New Age pilgrimage.

1994, Julian Richards: The complete Great Trilithon replica

DESECRATION (AND HARMLESS PRANKS)

With the exception of the pre-war incident involving the over-excited young Army officers Stonehenge stayed remarkably devoid of paint until the late 1950s. There were 'pranks' though. In July 1954 a coffin containing a rather academic-looking skeleton was found propped up against a trilithon by the custodian reporting for duty. The figure in the coffin was 'said to represent Professor Stuart Piggott' and the incident was put down to a Student Rag stunt.

The paint re-appeared over the night of 28 March 1959 when the stones were daubed with footprints, lines and circles, the names 'Maggie' and 'Sonja' and the words 'we want our......'. Quite what was wanted was never recorded, and the paint was removed by a local painter and decorator before any photographs were taken.

July 1954, Coffin and 'skeleton'
(NMR ALO 914/061/01 and ALO 914/062/01)

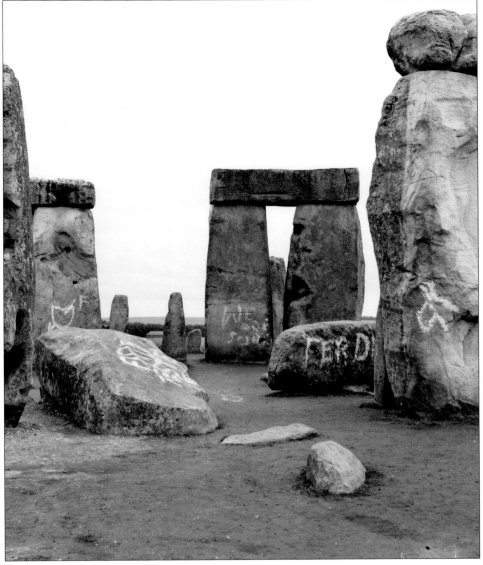

On Halloween, the night of 31 October–1 November 1959, the Head Custodian reported that people had arrived hoping for something to happen. There had been enquiries 'by bearded types'. Despite assurances that the presence of custodians should have foiled any pranks, the following morning Stonehenge was found to have been comprehensively painted. Alongside 'Elvis', who was presumably not a member of the party, the name 'Ferdinand' appears as well as 'Ferdie rested here' and 'Ferdie slept here'. Stone 53 was inscribed with the rather insincere message 'we are sorry'.

This time instructions were issued by the Superintendent of Works that the paint was not to be cleaned off until a Ministry photographer had recorded the damage. Much to the annoyance of the Head Custodian, this delay resulted in the paint drying hard.

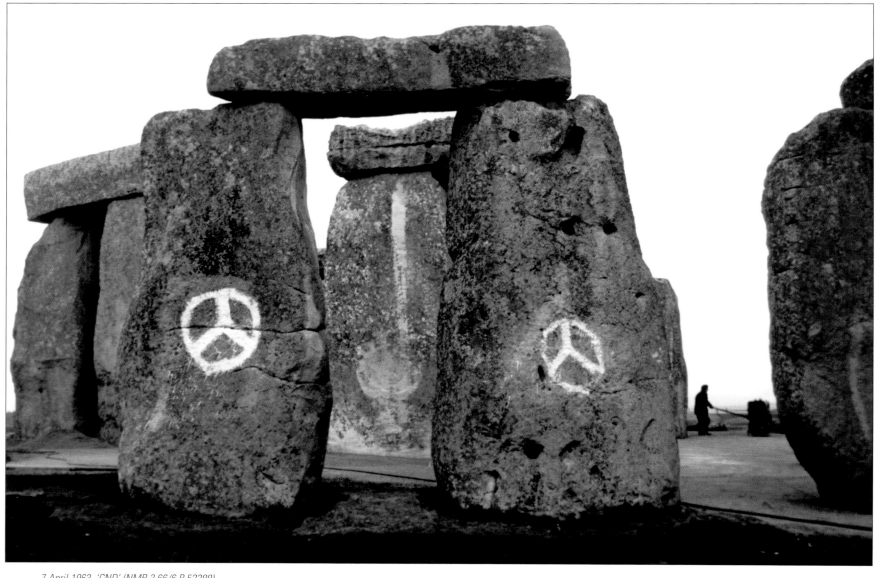

7 April 1963, 'CND' (NMR 2.66/6 P 52388)

The early 1960s saw the stones used as a canvas for political protest. On 2 March 1961 the words 'BAN THE BOMB' were painted in five-foot-high yellow letters on the stones of the outer circle.

These stones, which are the most visible from the road and offer the most extensive canvas, were targeted again two years later. The symbol of the Campaign for Nuclear Disarmament re-appeared on 7 April 1963 and was photographed by Atkinson, who happened to be on site.

1961 had been a strange year for graffiti. On March 2nd animal figures – cats, rabbits, dogs and other creatures – appeared. On 21 March the inside faces of a number of stones were inscribed with the enigmatic phrases: 'We don't believe the window test'; and, even stranger, 'the vicar is innocent'.

The 1960s, in keeping with the image of that decade, saw more strange happenings at Stonehenge. In 1963 students from Southampton held a party on top of some of the lintels, complete with tables, chairs and bottles of beer; and in 1964 a large model of an elephant, built by the London College of Fashion, was left in the centre of the stones. Also in 1964 a full-sized model lintel appeared filling a gap in the outer circle. It was made of timber and grey-painted canvas, and was signed 'Taurus Abundum' (lots of bull).

Unfortunately, though, Stonehenge became the target for more damaging student pranks. It was daubed on so many occasions that questions were raised in Parliament about how it could be better protected and a letter, expressing the concerns of the Ministry of Works, was sent to colleges and universities. This letter noted that Stonehenge 'appears to offer an irresistible attraction to those responsible for Rag Week stunts', and explained the damage that paint could cause to the newly discovered carvings and to the colonies of ancient lichen that encrusted the stones.

14 November 1967, T L Fuller: 'BATH RAG'
(NMR MPBW Photographs Collection)

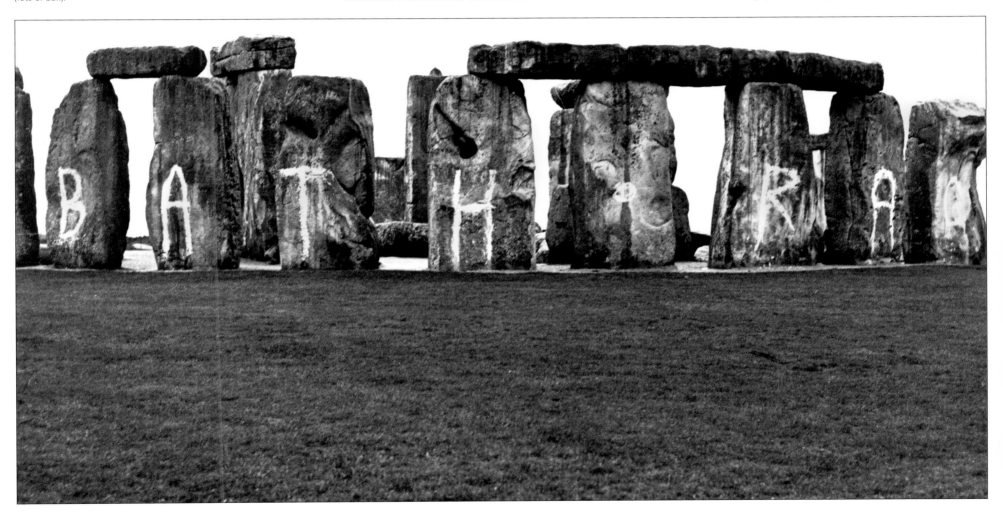

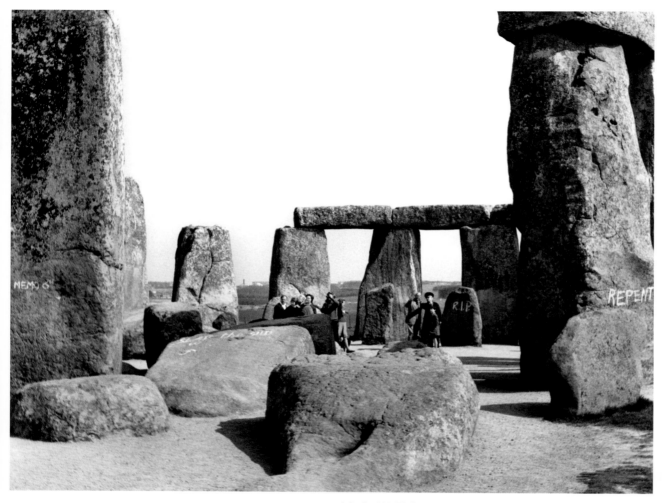

Among the universities directly implicated in the 1960s orgy of painting were Bath, Reading and Manchester. The four students from Manchester's Institute of Technology must be regarded as the unluckiest of the perpetrators, ending up in court and fined £78.5/- each after a bizarre set of events led to their arrest.

They had driven down to Southampton where they intended painting the SRN4, the world's largest hovercraft. However, they failed to find it and on impulse painted Stonehenge on their way home. At 4.00 am they ran out of petrol in Marlborough and were sold some by a policemen. When news broke of the vandalism at Stonehenge the policemen remembered the four young men in a van that smelt of paint and, as they had given him their names and addresses, they were not too difficult to track down.

8 April 1968, T L Fuller: Attributed to Reading University
(NMR MPBW Photographs Collection)

8 April 1968, T L Fuller: 'REPENT'
(NMR MPBW Photographs Collection)

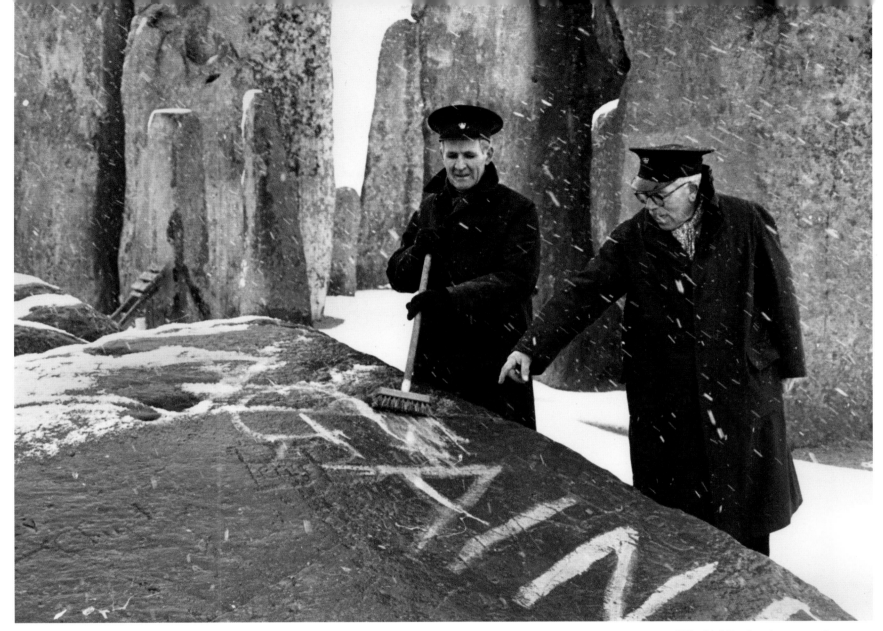

1960s, T L Fuller: Stonehenge custodians
scrubbing stones in the snow
(NMR MPBW Photographs Collection)

There were other incidents of painting at Stonehenge over the years. Pirate Radio stations, New Forest ponies and football clubs all made their marks and were duly cleaned off by local tradesmen armed with paint stripper and buckets of water. Occasionally, as in this undated photograph, it was the long-suffering custodians who ended up with the job. The message in this case appears to be written in distemper and is washing off easily. The face of the custodian with the brush suggests that he can think of places that he would rather be than in the centre of Stonehenge in a blizzard.

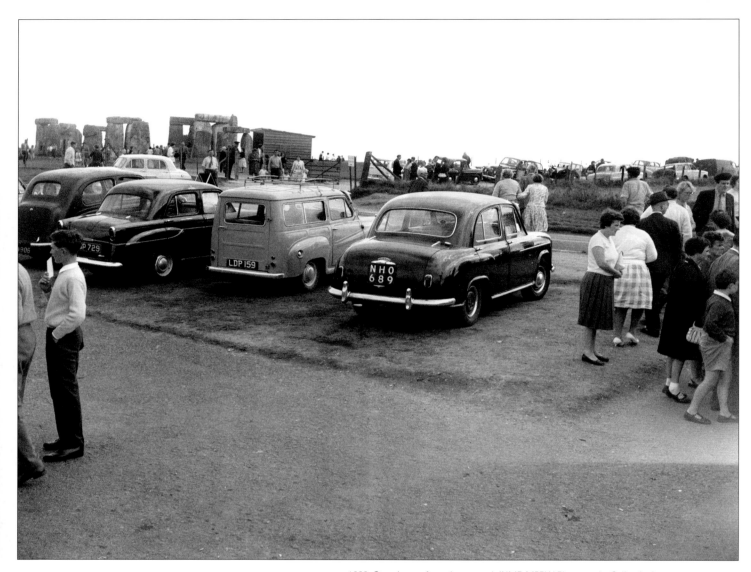

1960, Stonehenge from the car park (NMR MPBW Photographs Collection)

PRESENTATION

Just as the appearance of Stonehenge changed from 1901 onwards, with stones re-assembled, re-erected and straightened, so too did the way in which it was presented to the increasing numbers of visitors. As their annual numbers increased from thousands to tens of thousands and eventually, in the years after the Second World War, to hundreds of thousands, the ways in which they were allowed to experience Stonehenge inevitably changed.

1958, A summer visit to Stonehenge (NMR 28/198 P 51086)

By the late 1950s, little had changed in the way that visitors experienced Stonehenge in the years since the fence and the turnstile had first appeared. Cars could be parked either in the official car park by the side of the A344 or, before it was moved further west, on the verges of the track that ran north–south across Stonehenge Down.

Once the admission charge had been paid, access, under the watchful eye of uniformed custodians, was largely unrestricted, except during times of restoration or excavation.

In summer Stonehenge was a place for relaxation, a grassy picnic area with plenty of convenient stones to sit on or to climb if you were feeling more adventurous and the guardians didn't intervene.

1958, Climbing at Stonehenge (NMR 1207 P 51100)

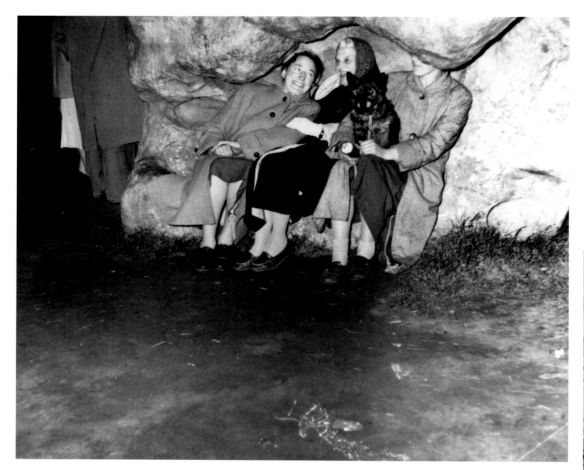

1958, Ladies sheltering inside Stone 60 (NMR 50/419 P 50384)

There were other uses to which the stones could be put, as demonstrated by this party of ladies who have found shelter inside the hollow base of Stone 60, the sole surviving upright of one of the fallen trilithons.

Sarsen, a type of sandstone laid down in warm shallow seas, varies considerably in its composition and hardness. The slabs into which it naturally fractures often have one rough side and one that is much smoother. Holes made by the roots of aquatic plants and burrowing marine creatures create weaknesses that weather can modify and enlarge, the stones sometimes taking on fantastic shapes and contours. The base of Stone 60 had eroded into what was effectively a tiny cave, just big enough for three at a squeeze.

1959, Stone 60 is given a filling (NMR A 84 – 38/161)

In 1959 Stone 60 was straightened and, at the same time, in order to deal with what was seen as a weakness in its structure, the 'cave' in its base was filled in. Here the wooden shuttering is constructed prior to pouring in the concrete. No more would it provide shelter for ladies caught in a sudden shower.

The end result of the filling of Stone 60 can confuse visitors, even though it is a good example of very honest restoration, with no attempt being made to disguise modern work as ancient stone. There was also no disguising the next major change that took place in the centre of Stonehenge, the arrival of the gravel.

1964, Stone 60 restored (NMR MPBW Photographs Collection)

March 1963, Gravelling the interior
(NMR: no further reference)

As Stonehenge became more popular and the numbers of visitors increased, so the combined erosive power of their feet had a greater effect on the area around the stones. In summer, the grass was worn away into bare earth; in winter, it could become a muddy swamp. So the problem was solved by taking the grass away. It was replaced by a layer of clinker, obtained from the gasworks at Melksham, here seen being rolled down, and was topped off with Breedon gravel. The end result was the standardised, rather soul-less appearance that was shared by so many monuments, from stone circles to ruined castles, throughout the 1960s. Mercifully the suggestion made at the end of the 19th century – that the stones should sit in a sea of asphalt – was not taken up.

By 1973 the old car park had gone, as had the track that for so long provided additional parking space. In its place was a new and much larger car park, with additional visitor facilities. These included an office for the custodians, a shop and toilets. In earlier years it had been suggested that there was no need for toilets, as visitors had the whole of Salisbury Plain as an outdoor facility, but times had thankfully changed.

Since 1968 there had also been no need to risk life and limb by crossing the A344, as a pedestrian underpass led under the road to Stonehenge. The visitor was then conducted, by means of a gravel path, directly into the stones. There seems to have been no encouragement to explore any other part of the monument – the Heel Stone is even surrounded by its own protective fence.

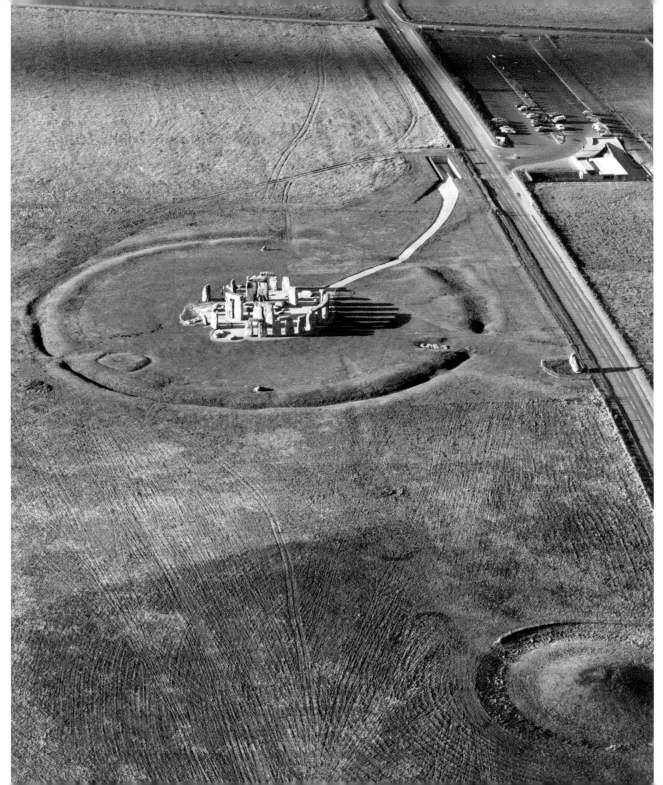

26 November 1973, Aerial view from the east (NMR SU 1242/99)

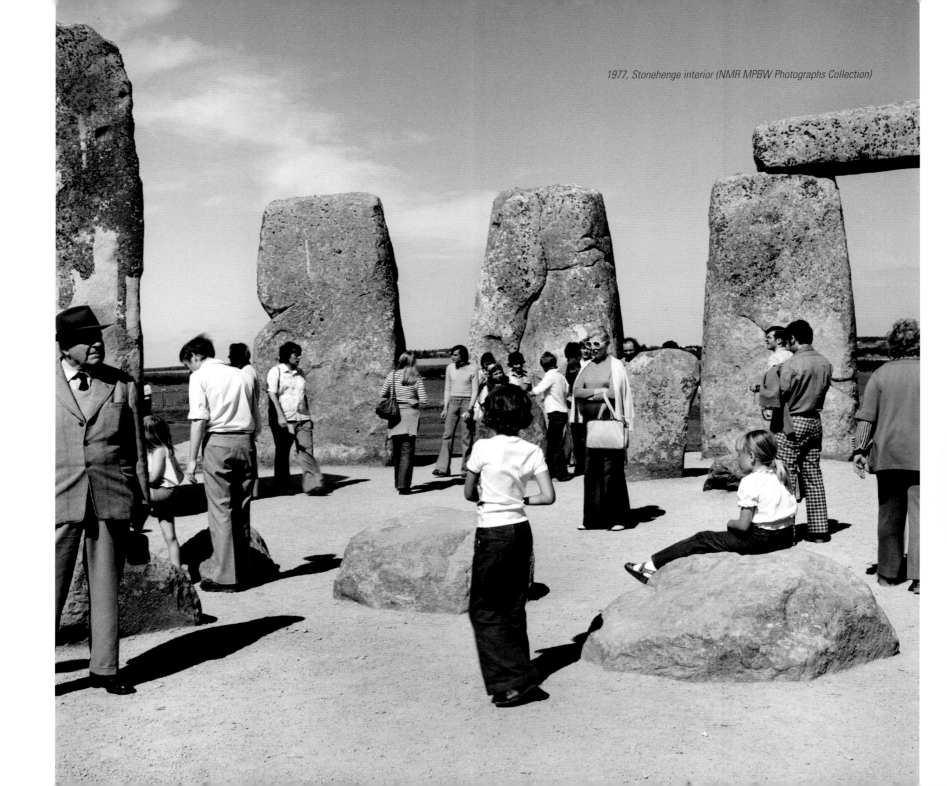

1977 was to be the last year of unrestricted access, the freedom to stroll on the gravel, to sit on the stones, to simply stand and stare. There had been a creeping realisation of the damage caused to the stones by the gravel that had seemed such a neat and visitor-proof solution to the problems of a grassy interior. In windy weather it blew around and effectively grit-blasted the lower portions of the stones, removing their covering of ancient lichens. Visitors picked up gravel in the soles of their shoes and then stood on the fallen stones, gradually grinding them away.

After fourteen years it was decided that the gravel had to go. But if the gravel went from the centre of Stonehenge, then so, unfortunately did the visitors.

On 15 March 1978 the signs went up explaining that because of damage, visitors were no longer to be allowed access to the stone circle. There were immediate protests. Under the banner of 'S.O.S.' (Save our Stonehenge) a petition was raised with the aim of having Stonehenge re-opened 'for you and everyone'.

Official minds were not going to be changed, even though this was a very unpopular decision. Looking after Stonehenge will always be difficult, balancing the responsibility of safeguarding fragile archaeology against the wishes of visitors for a complete 'experience'. By the late 1970s, however, Stonehenge was attracting more than two thirds of a million visitors a year and the stones, which occupy a comparatively small area, simply could not cope.

1978, Access denied (English Heritage Amesbury Office)

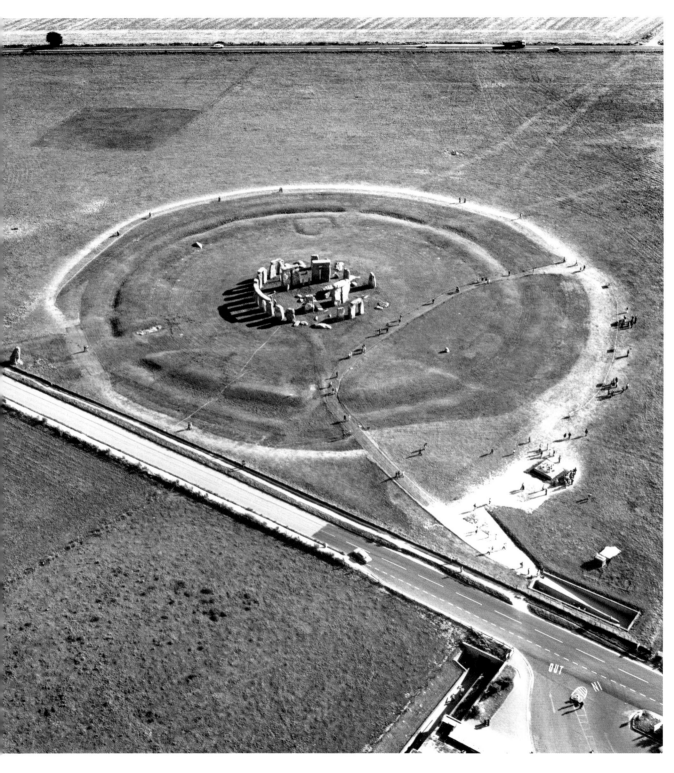

By the autumn of 1978 the gravel had been removed, the interior of Stonehenge was once again grassed over and the nearest a visitor could get to the stones was on the path that looped into the enclosure, following the line of one of the old tracks. This was a concession to give at least some sense of the scale of the stones, which is lost if they can only be seen from outside the earthworks. A scale model was also set up close to the exit from the underpass.

As the newly-worn path clearly shows, visitors had started to walk around the entire circuit of the earthwork enclosure. It was hoped, despite being disappointed at not being allowed among the stones themselves, they might have gone away with a better impression of Stonehenge as a whole.

To be realistic, nothing more of Stonehenge can be restored. The two collapsed trilithons each have one upright still standing but their other stones are so smashed and eroded that reconstruction would be impossible. Enough survives of the outer circle to imagine its appearance when complete; and the bluestone settings, in which some of the stones have dissolved entirely through the action of wind and rain, must remain fragmentary.

Stonehenge is and always will be quite simply, a magnificent ruin.

19 September 1978, Aerial view from the north-west
(NMR SU 1242/118 (29124))

19 September 1978, The stones from the east
(NMR SU 1242/122 (29128))

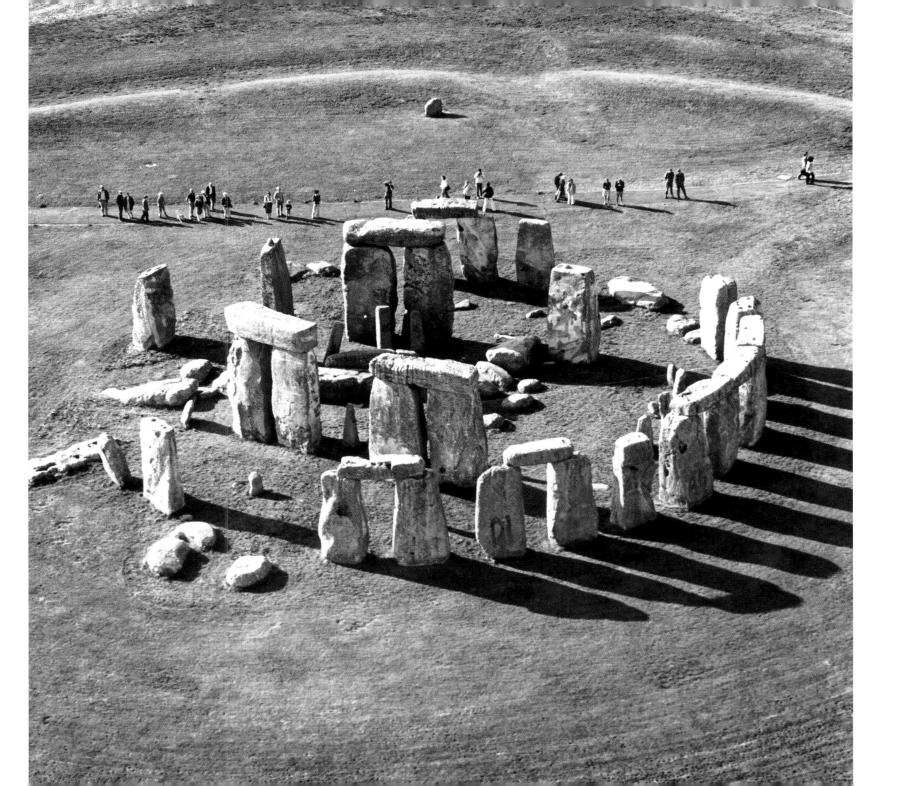

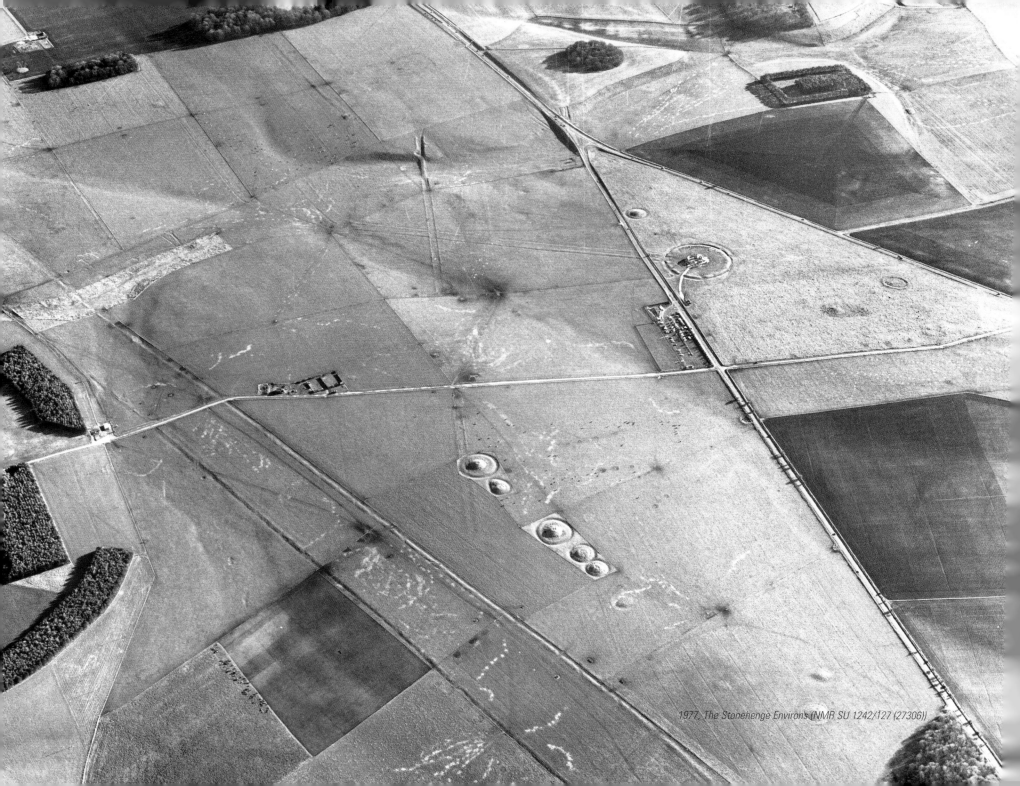

1977, The Stonehenge Environs (NMR SU 1242/127 (27306))

It is easy to see Stonehenge in isolation, as a single prehistoric site surrounded by a modern landscape of roads and fields. But this landscape is rich in prehistoric remains, some, like burial mounds and ceremonial pathways, still visible today, others less obvious. In the 1970s the evidence from more than sixty years of aerial photography was brought together by the Royal Commission on the Historical Monuments of England (RCHM). This revealed a hidden landscape of ancient fields and meandering boundaries, now visible only as marks in bare soil, growing crops and parched grass. This new dimension of the ancient past was then studied in greater detail by Wessex Archaeology during the 1980s. Hundreds of thousands of prehistoric finds were collected from the surfaces of ploughed fields. Analysed, plotted out and in some cases their locations excavated, they provide the evidence for the everyday lives of the people who built and used Stonehenge.

This view shows part of the Stonehenge Environs, a term coined by the barrow digger and pioneering archaeologist Sir Richard Colt Hoare. Stonehenge lies to the right in a triangle of land bounded by the A344, the A303 and the track that runs from Larkhill Camp in the north, southwards to Normanton Down and beyond.

The Avenue runs out straight from Stonehenge in a north-easterly direction and is cut by the earthworks of a 17th-century road, which carries on westwards and clips the edge of a large Bronze Age round barrow. This is part of a group known as the Cursus Barrows, all of which were excavated by Colt Hoare and Cunnington in the first decade of the 19th century.

Their name comes from the strange monument to which they run parallel, the Stonehenge Cursus. This is a huge elongated enclosure, more than 100m wide and nearly 3km long, which runs east–west across the undulating chalk downland to the north of Stonehenge. Its width is marked by the parallel field boundaries that run diagonally across the lower part of the photograph. Thought by its discoverer, the 18th-century antiquarian William Stukeley, to be a Roman Racetrack, it is now known to be a ceremonial enclosure dating to c 3000 BC, the time of the first Stonehenge. Its eastern end lies on the King Barrow Ridge, where ancient beech and yew woods hide some of the largest round barrows in the Stonehenge landscape.

Beyond the triangle of land in which Stonehenge lies, almost all the land shown in this aerial photograph is owned by the National Trust. During the past thirty years important but subtle changes have taken place within their Stonehenge Estate. Earthworks have been restored, cultivated fields have been returned to grass, and fences have been removed or carefully re-sited in the folds and hollows of the downs. Visitors are now encouraged to explore the landscape and see Stonehenge in its ancient setting, not in isolation, but surrounded by great ridge top cemeteries of burial mounds. It is this relationship, between the great central temple and a landscape in which all ancient human life (and death) is represented, that makes Stonehenge of such huge importance. It is for this reason that this landscape, together with the complex of monuments around Avebury in north Wiltshire, has been designated as a World Heritage Site, recognised as being of international importance.

Too many changes have taken place for the prehistoric landscape ever to be recreated. But the fragile monuments from those ancient times that have survived can be better understood and better protected for the future in today's evolving landscape.

1958, Druid at the Heel Stone (NMR 57/478 P 50439)

1958, Druids at night with army escort (NMR 1199 P 51092)

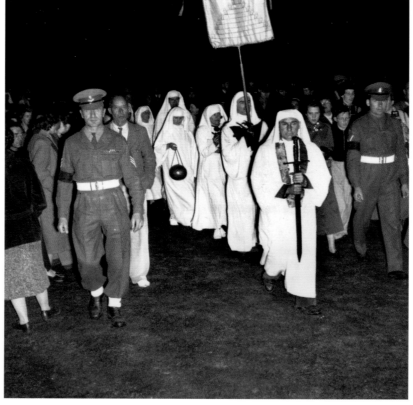

In more recent times there has been a revival of celebration at Stonehenge, by those who see themselves as the rightful heirs of its ancient past. To many, it is a living temple and a universal symbol of some long-lost ancient freedoms. Druids and pagans, and those who have been inspired by Stonehenge to acts of creativity, have all added their own brand of celebration.

There has also been conflict, in which Stonehenge unfortunately became less a symbol of ancient values and more a focus for modern grievances.

Of those who have celebrated at Stonehenge in recent times the Druids, or rather their modern incarnation, have been the most consistent. Despite this persistence, no Druid, either ancient or comparatively modern, has any genuine association with Stonehenge. There were Druids in prehistoric times but they were an Iron Age priesthood that flourished just before the Roman conquest of Britain in AD 43. So they could have had little to do with Stonehenge which, by the early 20th century, had been clearly demonstrated as dating to the Neolithic or early Bronze Age, nearly 2000 years before the Romans arrived. There was also the additional problem that the Ancient Order of Druids are not in fact, very ancient at all, having only been founded in AD 1781. This did not deter them from effectively laying claim to Stonehenge and their mass initiation in 1905 was just the first of many visits.

The Summer Solstice celebrations of 1958 were captured on film by Richard Atkinson: a military escort, barbed wire around the Heel Stone, a harpist and, to judge by the umbrellas, not very pleasant weather.

In more recent years Druidism appears to have become somewhat more factional and at times it is difficult to know which specific branch has actually visited Stonehenge. Among those listed alongside the Ancient Order of Druids (AODS) have been the Glastonbury Order of Druids (GODS) and the Secular Order of Druids (SODS). The ceremonies, which in the 1950s were enlivened by harps and viewed with respectful curiosity, tended to become overwhelmed as the numbers attending the Summer Solstice grew.

This has long been the traditional date for celebration at Stonehenge, the 21st June (or thereabouts) – Midsummer – the longest day of the year. This is the time when the sun is at its farthest distance from the equator and for a short period rises in the same location (Solstice means 'standstill') before resuming its movement across the horizon. At Midsummer dawn,

CELEBRATION AND PROTEST

Stonehenge was built for celebration. The alignment of the earthwork enclosure and the stone settings suggest that the celebrations were held at specific times of the year, connected with the longest and shortest days. The vast effort that went into building the structure of Stonehenge means that these ceremonies must have been of great importance to the people of that time. What form they took, however, is a mystery, the only evidence lying in the layout of the stones and the few objects that were deposited during these remote times. Imagine if the only evidence for Christianity was what could be deduced from the bare ruined structure of a church or cathedral. It would be a very poor understanding of a complex set of beliefs and the elaborate ceremonies that reflected them.

1958, Druid and harpist (NMR 57/481 P 50442)

weather permitting, the sun, viewed from in front of the Great Trilithon, rises over the Heel Stone to the sound of shouts, trumpets and, in more recent years, badly played drums.

There is an alternative though – not Midsummer but Midwinter, half a year later at the other standstill that occurs around the 21st December. At this time of the year, when Stonehenge was less ruinous, and facing in the opposite direction, with your back to the entrance and the Avenue, the sun could have been seen setting between the uprights of the Great Trilithon. The collapse of this part of the structure has denied the modern observer what, with a rapidly descending blood-red winter sun, must have been a memorable experience.

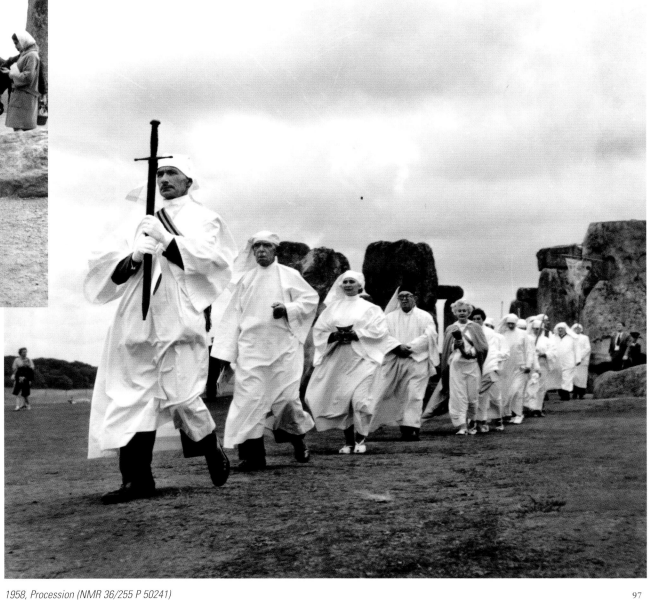

1958, Procession (NMR 36/255 P 50241)

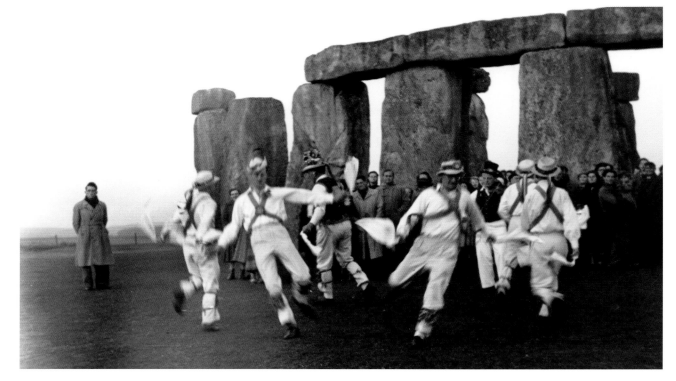

The activities and accessories of modern day Druids can at times seem puzzling, but replace harps, sickles and mistletoe with handkerchiefs, sticks and ragged clothes and Morris dancing can seem equally strange to the uninitiated. In 1956 Morrismen, carrying on a tradition far more ancient than those of the supposedly ancient Druids, could entertain their audience adjacent to the stones. By 2001 they were relegated to the outer limits of Stonehenge, to provide a rival focus of attention for the visitors.

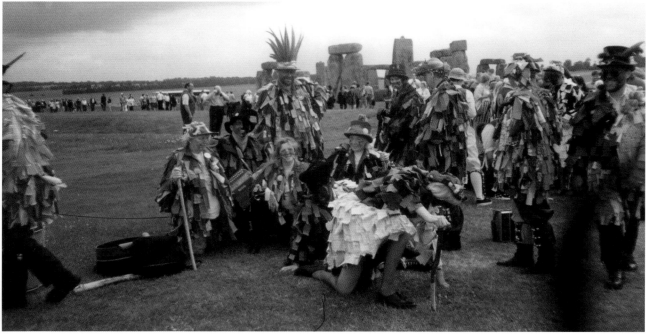

1956, Morris dancers (NMR 1.84/31 P 51770))

2001, Morris Dancers (English Heritage Amesbury Office)

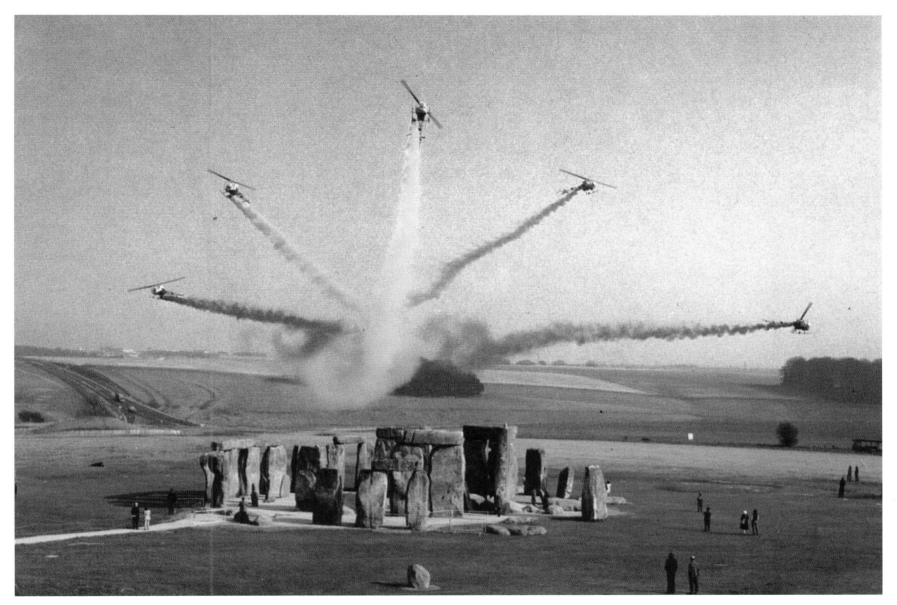

1968, The Blue Eagles *over Stonehenge*
(Museum of Army Flying; © Crown Copyright/MOD)

In celebration of Stonehenge, or perhaps of their skills in flying helicopters, the Blue Eagles, the Army Air Corps display team, perform a 'Spread Eagle' over Stonehenge.

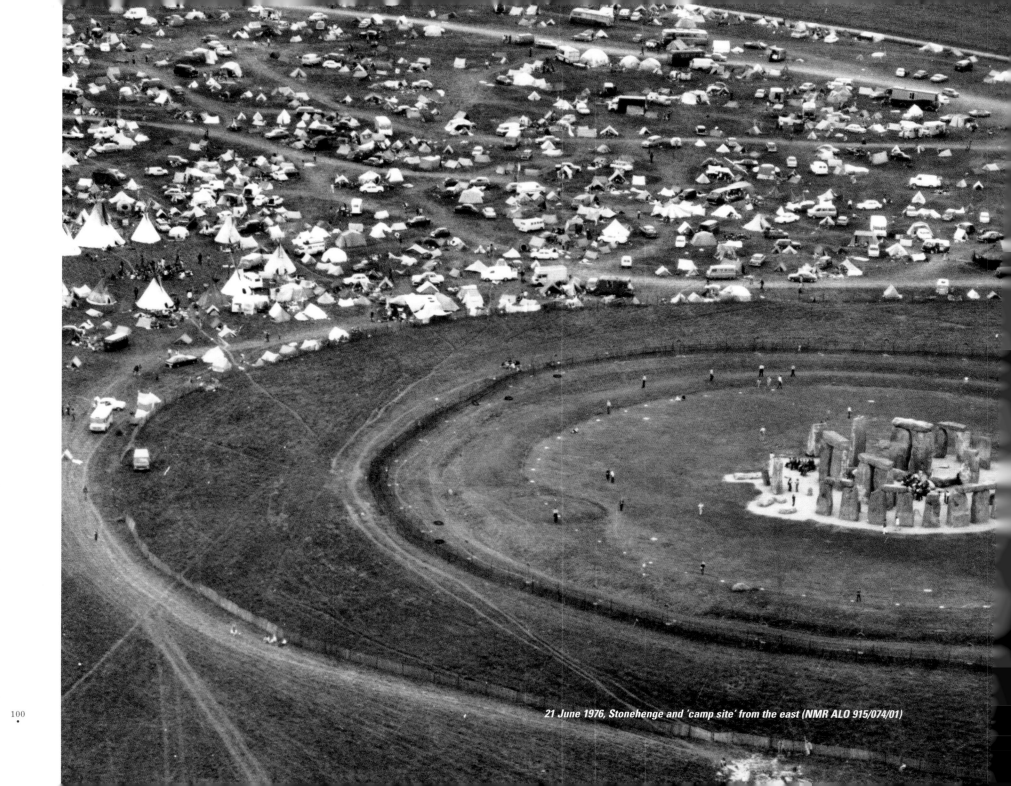

21 June 1976, Stonehenge and 'camp site' from the east (NMR ALO 915/074/01)

In 1974, after most of those who had gathered for the Summer Solstice had gone home, a group calling themselves the Wallies of Wessex decided to stay on for a while. This happened again in the following year, and by 1976 (photograph, left) the Summer Solstice celebration had grown into the anarchic event that was known as the Stonehenge Free Festival. Apparently devoid of organisers, leaving no-one to be taken to court, it started life on the triangle of land between the A303, the A344 and the drove road, but after a few years outgrew this site and moved slightly further north.

The Stonehenge Free Festival in full swing in 1982. The official car park is still in use, bemused visitors still arrive by the coachload, the stones are occupied, and in the background is the festival field. For several weeks around the time of solstice, this field, devoid of the most basic facilities, was home to thousands who gathered to hear music from famous bands such as Hawkwind and less famous ones like Flux of Pink Indians. The Cursus barrows can just be seen poking out of the sea of cars, vans, buses, tents and tepees. Raising a flag on one of the barrows, weeks before the Summer Solstice, was the signal for the fence to be cut and the festival to begin.

Weeks, sometimes months, later the field would finally be vacated leaving piles of rubbish and in later years a collection of burnt out cars.

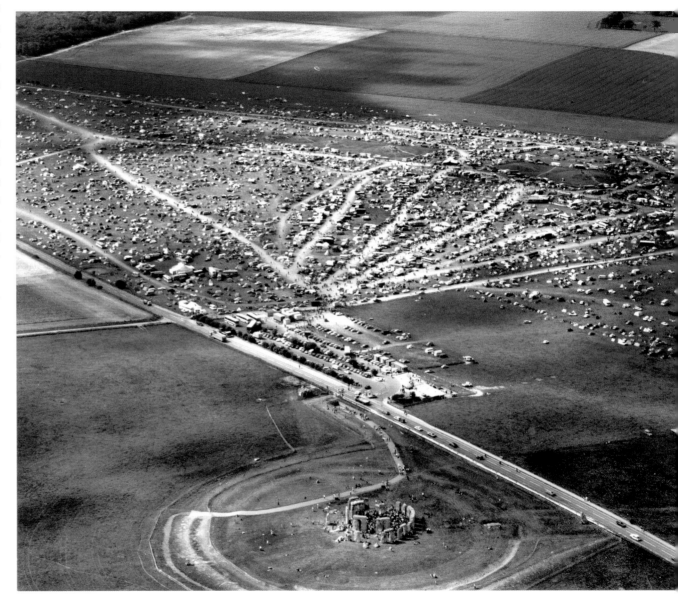

June 1982, Alan Lodge: the Stonehenge Festival in its new home

Midsummer 1985, Julian Richards: The approach to Stonehenge

In the mid 1980s this was the first view of Stonehenge at Midsummer heading westwards along the A303. Blocked off roads, notices stating that processions (defined as being more than two people) were banned and an air of tension prevailed. Stonehenge became a fortified enclave, ringed with razor wire, patrolled by security guards with dogs, while Police helicopters hovered overhead. All this was to deter the New Age Travellers, who were determined to reach the stones at all costs. Ticket holders, including journalists and film crews, were bussed in through the fortifications for the Midsummer dawn but there were no real celebrations at Stonehenge during these troubled years.

In its original incarnation the Free Festival was always intended to be anarchic, but essentially peaceful – a celebration of home-made mysticism centred on Stonehenge. However, its popularity and consequent increase in scale, the overt drug dealing and an increasingly confrontational element within the New Age Travellers who formed part of the festival community eventually led to its demise in 1984.

The National Trust, who had played unwilling host to the Festival and its aftermath, breathed a sigh of relief. Others missed the annual carnival. 'I want to go to Stonehenge in peace and play my flute again' – Dice George, *Festival Eye* article 1989.

1982, Midsummer, playing among the stones
(Wiltshire Record Office P 11400)

15–16 September 1989,

Richard Albright: 'Fires of Beltane'

English Heritage, the guardians of Stonehenge since 1984, can grant special access to the stones outside normal opening hours. In September 1989 Richard and Jodeane Albright, from Idaho, USA, were given permission to spend two nights inside Stonehenge taking photographs with flashlights and a torch. They had, in Richards words, 'a most wonderful time'.

Richard describes his striking photographs as 'painting with light', an attempt to show what the stones might have looked like in some far distant past.

15–16 September 1989,

Richard Albright: 'The Lady of Stonehenge'

Jodeane Albright, the 'Lady of Stonehenge', felt overwhelmed by the stones that she saw, once inside them, as towering yet protective, a testimony to what humans can do. Jodeane felt that being naked at that time and place was the right thing to do – an appropriate way to be a part of the history of the stones. It was also, as she recalls, 'damn cold!'.

In 1986 John Timothy Rothwell assumed his true identity as Arthur Uther Pendragon and has since risen to become a major and respected figure among the new Druid groups. Pendragon of the Glastonbury Order, the Swordbearer of the Secular Order and leader of his own Loyal Arthurian Warband, King Arthur, former soldier and biker, is now part mystic, part civil rights campaigner.

In September 1990, in his early days of campaigning, King Arthur mounted an official picket at Stonehenge to protest against the exclusion of his Warband, the Grand Council, of Druids and the Free Peoples from the Autumn Equinox.

This was certainly not the last that would be seen of King Arthur and his ceremonial sword Excalibur.

September 1990, Julian Richards:
Autumn Equinox protest by King Arthur

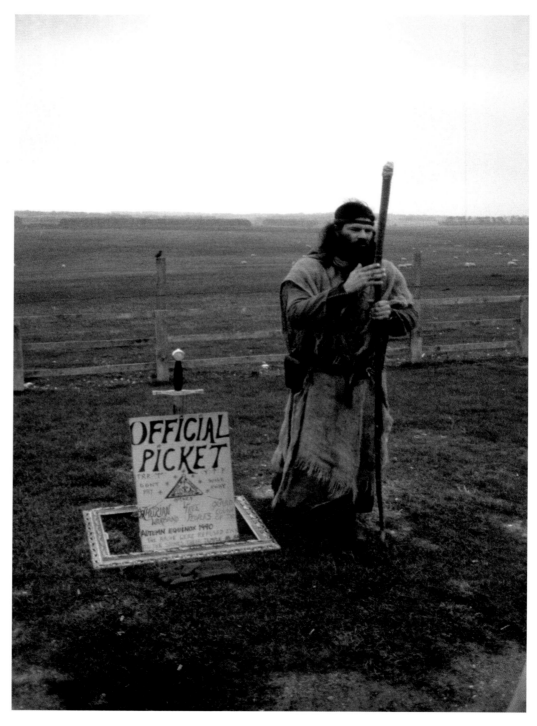

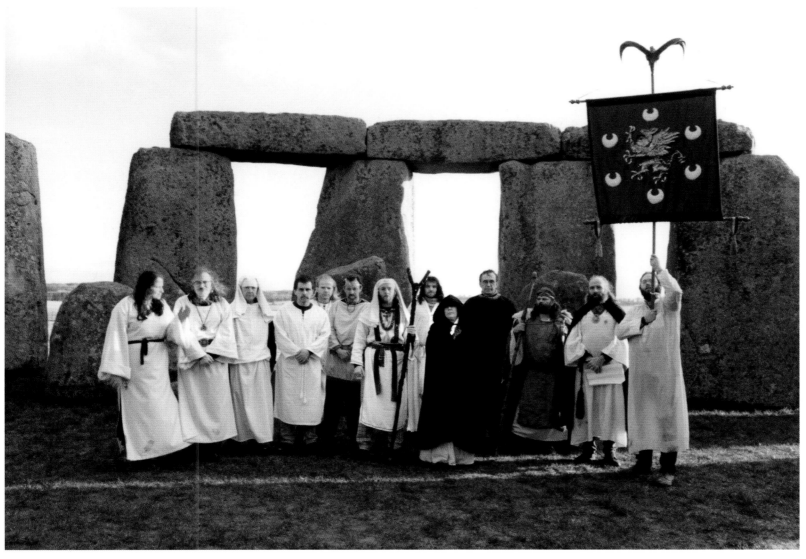

February 1995, Druid initiation (English Heritage Amesbury Office)

Ninety years after the mass initiation held by the Ancient Order of Druids at Stonehenge, another initiation took place on a freezing day in February. Members of the Glastonbury Order of Druids, the Insular Order of Druids, the Druid Clan of Dana and the Arthurian Warband took part in a ceremony that began before dawn. In what must have been a test of endurance the initiates were blindfolded and bound outside the circle, then led in to be reborn within the stones when the sun had risen.

Protest, or perhaps celebration of a political nature, was not dead at Stonehenge though. On Monday 8 May 1995 Stonehenge was occupied all day to commemorate the 50th anniversary of the defeat of Nazism. Of the 100 or so that gathered that day with banners and music, some were from the festivals that had ended more than ten years before, but most were in the stones for the first time, a new generation of eco-activists from anti-road campaigns at Twyford Down or Newbury.

8 May 1995, VE Day protest, Criminal Justice Act
(English Heritage Amesbury Office)

The Autumn Equinox and its equivalent in spring, falling midway between the two solstices, are important events in the Druid calendar, the time when day and night are of equal (or equi-) length.

In 1990 King Arthur had picketed Stonehenge in protest at the exclusion of Druids from the stones at the time of the Autumn Equinox. Seven years later the Druids were welcomed in. 1997 marked the real beginning of a new era of compromise and co-operation after the years of confrontation and exclusion. The numbers were small, the costumes eclectic for this 'ecumenical alternative religious gathering', but the threat of violence had gone and celebration had returned to Stonehenge.

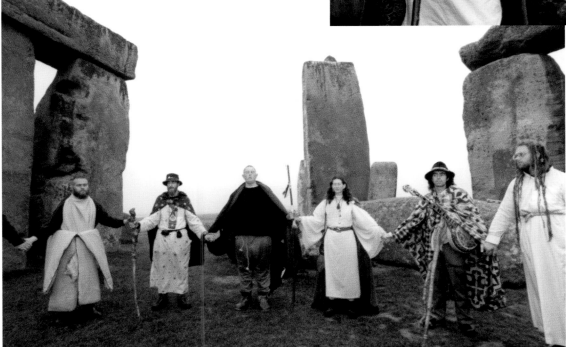

21 September 1997, Peter van den Berg: Druids celebrate the Autumn Equinox (English Heritage Amesbury Office)

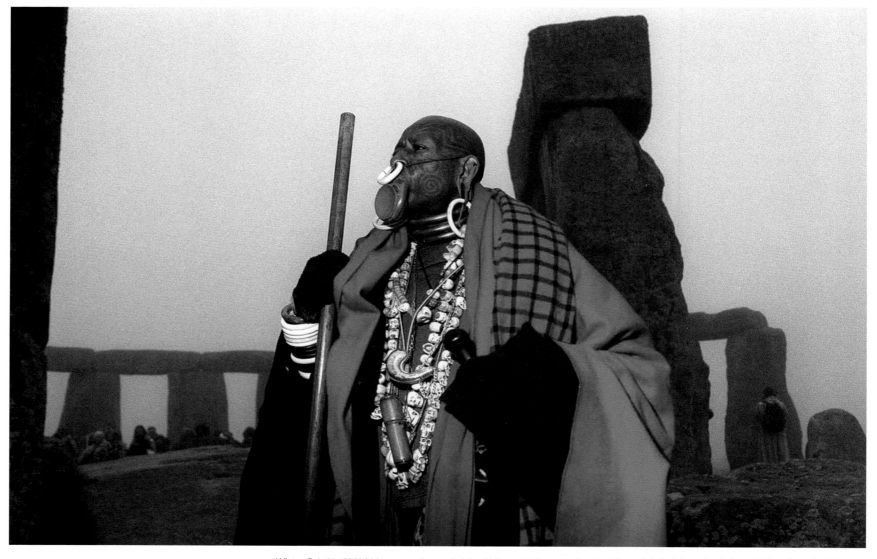

Winter Solstice 2000 (this page and opposite), Les Wilson: 'At Peace During the Winter Solstice', featuring Lebaya Ol Dinyo Laetoli of Tanzania

Wiltshire has become the crop circle capital of England. Each summer more and more elaborate patterns appear in growing cereal crops, sharply dividing opinion between those who see them as extra-terrestrial messaging and the sceptics who point to the fact that many of them have been demonstrated as being the work of artists exploring a new medium.

On 7 July 1996 this complex pattern appeared just south of the A303 close to Stonehenge. It consisted of 151 separate circles and, according to some sources, appeared within the space of fifteen minutes in broad daylight. Far from being annoyed at the destruction of his crop, the landowner erected a booth and collected a fee from those who wanted to experience a crop circle at first hand. To add to the mystery, visitors to the circle reported sudden headaches and inexplicable camera malfunctions.

7 July 1996, Crop circle south of Stonehenge
(NMR SU 1241/66 (15453/02))

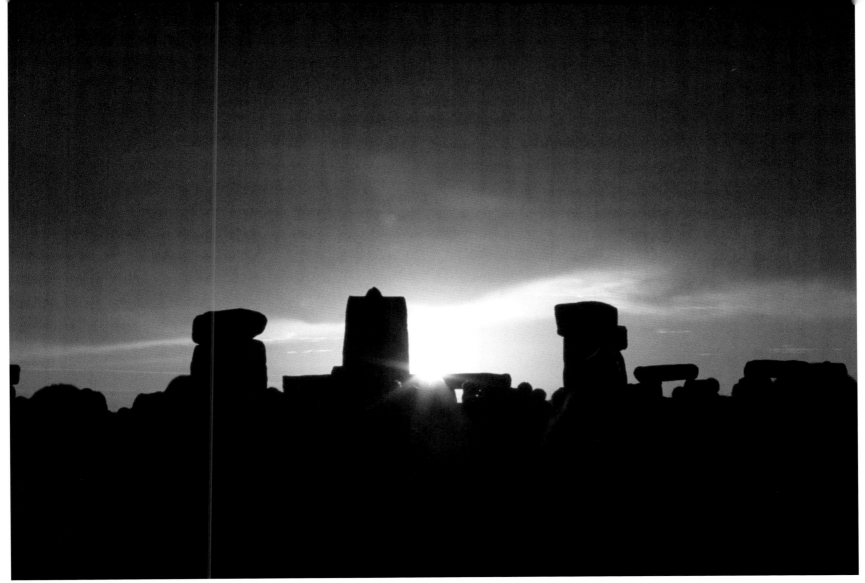

21 June 2003, Julian Richards:
the Summer Solstice

The Summer Solstice at Stonehenge is now an extraordinary event. On the evening before Midsummer Day the last visitors are ushered from the site at the usual closing time as a stream of vehicles turns off into a huge grass car park about half a mile to the west. As darkness falls, the A344, closed for the night, becomes a processional way leading to Stonehenge. At midnight the stones are open to all. In 2003 more than 30,000 gathered for a night of carnival, music, processions. Druids are in attendance, King Arthur and his Warband defuse any minor tensions but solemn ceremonies are drowned out by the cacophony of drumming and the great roar that greets the first light of dawn over the stones. 2003 was a peaceful celebration and a spectacular dawn. It was a privilege to be there.

Stonehenge in 2004

The photographs in this book chart 150 years of change at Stonehenge. Over these years restoration has altered its physical appearance and it has been presented to the visiting public in many different ways. Our understanding has grown too, with science providing answers to some fundamental questions, such as when was Stonehenge built, and who built it?

As far as the structure of Stonehenge is concerned we can be certain where the stones came from. Geology tells us that the sarsens are from the Marlborough Downs and the bluestones from the Preseli Mountains in Wales. Although there are still some who prefer to think of the stones having been transported by means of glacial ice, most accept that humans were the means of delivery. The reason why stones were selected from such a remote location as Preseli is difficult to understand, although recent fieldwork in this area has shown it to be peppered with prehistoric monuments and far from wild and uninhabited at the time of Stonehenge. Perhaps the idea for Stonehenge itself originated in Wales, perhaps what arrived on Salisbury Plain was not simply building material but a complete stone circle, dismantled and exported. The announcement in June 2004 that early Bronze Age burials found near Amesbury had been demonstrated to be of people born in Wales just added to the chorus demanding that Stonehenge be recognised as a Welsh monument.

We can now state with confidence when Stonehenge was built. Radiocarbon dating has come a long way since Professor Libby announced his first dates in 1952. Only tiny samples of organic material such as bone, antler or charcoal are now required, but the dates determined from the samples are far more precise. Using pieces of the antler picks and animal bones recovered by Hawley and Atkinson, English Heritage's dating expert Justine Bayley has calculated that the ditch was dug between 3000 BC and 2930 BC. The stones started to appear in around 2500 BC and the huge task of construction continued over a period of approximately 500 years.

Now we can be certain *when* Stonehenge was built; we can also be fairly certain about *who* built it. Not outsiders, like the Myceneans, but the native inhabitants of Neolithic and Bronze Age Britain.

The first Stonehenge, the simple bank and ditch enclosing the circle of Aubrey Holes and some possible timber structures, was built in the earlier part of the Neolithic, at a time where there was very little outside influence on the indigenous culture of the British Isles. However, the five centuries during which the stone structures were erected, is a time of considerable change during which continental influences start to be felt strongly in Britain. In around 2300 BC the first metals arrive: copper and bronze, *even* gold. The technology, the ability to perform what must have been a magical transformation, from dull rock to shining metal, comes from mainland Europe, and with the technology and the metal, came people.

In 2002 a spectacular burial was unearthed near Amesbury, dating to around 2300 BC and the richest burial of its kind in Britain. The skeleton of a man lay in a chalk cut grave with a collection of flint arrowheads and distinctive 'beaker' pots that characterise these first metal users, bronze daggers and gold.

To the popular press this man was the 'King of Stonehenge' and the fact that isotopes in his bones revealed that he was born in central Europe, perhaps close to the Alps, once again raised the possibility of foreign influence in the building of Stonehenge. The reality is probably less dramatic. There clearly were incomers but even with their fabulous wealth, based on the trade in new luxury goods, it is unlikely that they would have been able to simply take over the building and running of Stonehenge.

Archaeology is good at answering questions on the lines of what, when and how? In prehistoric times, with their absence of any written records to back up the findings from excavations, the questions of 'why?' is often less easy to answer. We believe Stonehenge to be a temple to the sun: its central axis, the line drawn through the horseshoes of stones, out through the main entrance and down the line of the Avenue, aligned on the rising of the sun at Midsummer and its setting at Midwinter. It seems likely that its builders and users would have been more concerned with the Midwinter Solstice, the time when the sun appears to be dying before its rebirth heralds the promise of another spring. To early farmers, whose lives depended on the success of their crops and the well being of their herds, the turning of the year would have been of vital importance, a time of fear and of celebration.

December 2003, James O Davies (NMR K022290)

Midsummer, or midwinter, Spring or Autumn Equinox, other times of importance in the solar calendar, whatever ceremonies took place are lost to us. The science of today cannot recreate the atmosphere and sound of the past when garlands of flowers, processions, eating and drinking, perhaps even sacrifice, might have been a part of Stonehenge's year. This is why Stonehenge is so alluring, because in the supposedly rational world of today, where everything should be capable of explanation, it remains genuinely mysterious.

We may think we understand Stonehenge, but it will always keep some of its secrets, shrouded in the mists of time.